Fr Browne's
Trains and Railways

Dedicated to the memory of my uncle
Thomas Garland
who died November 2004.
In 1920 his first job involved running around
Athlone before dawn making sure that the
GSR railwaymen were awake.

Fr Browne's
Trains and Railways

E. E. O'Donnell

CURRACH PRESS

First published in 2004 by
CURRACH PRESS
55A Spruce Avenue, Stillorgan Industrial Park,
Blackrock, Co Dublin

www.currach.ie

1 3 5 7 9 10 8 6 4 2

Cover by Currach Press.
Front cover photograph shows Great Southern Railways
locomotive Number 403 preparing to depart from
Kingsbridge Station, Dublin (1933).
Back cover photograph shows the 'non-smoker', Portarlington, Co Laois (1931).
Origination by Currach Press.
Printed by Nørhaven Book A/S, Denmark.

ISBN 1-85607-916-3

Father Browne prints are available from Davison & Associates,
69B Heather Road, Sandyford Industrial Estate, Dublin 18.

Contents

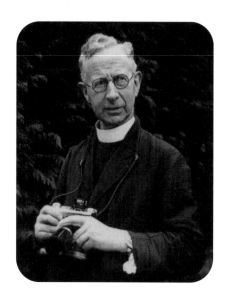

Father Frank Browne SJ

There was a time when Father Browne was best known as the priest who photographed the *Titanic*. The book containing those photographs was a best seller in the 1990s on both sides of the Atlantic and indeed on both sides of the Pacific. The pictures were exhibited in places as far apart as Hiroshima and Orlando. Father Browne, however, took less than one hundred photos when he sailed on that famous maiden voyage. With a book of his work coming out nearly every year, he is becoming more famous for the 42,000 other pictures he took during his long career. It was his Irish images, for example, that were shown at the Pompidou Centre in Paris as well as in Portugal, Germany and Belgium. Australia and England have seen exhibitions of the photographs taken in those countries. The Guinness Hopstore Gallery in Dublin has displayed the superb pictures of Ireland's capital in 'the rare ould times' and RTÉ – Ireland's national broadcaster – has twice aired *The Day Before Yesterday*, a six-part documentary first produced in 1994 using Father Browne's photographs to illustrate the pre-war years.

For readers not yet familiar with the details of Father Browne's adventurous life, let me outline its highlights. (A biography, *Father Browne: A Life in Pictures* was published by Wolfhound Press in 1994.)

Born in Cork in 1880 Francis Mary Hegarty Browne, a grandson of the lord mayor, was educated at the Bower Convent, Athlone; at Christian Brothers College, Cork; at Belvedere College, Dublin and at Castleknock College, County Dublin. In 1897 he toured Europe with his camera and, on his return to Ireland, joined the Jesuit Order. After his two years of noviceship, he attended the Royal University in Dublin where he was a classmate of James Joyce. He is mentioned several times in *Finnegans Wake*.

From 1902-1905 he studied philosophy in Italy and then taught at Belvedere College until 1911. The following year, while studying theology at Milltown Park in Dublin, he received a pleasant surprise. His uncle, Robert Browne, the Bishop of Cloyne, sent him a first class ticket for the first two legs of *Titanic's* maiden voyage, from Southampton to Cherbourg and thence to Queenstown (now Cobh) in the south of Ireland.

In 1915 Frank Browne was ordained a priest and immediately sent to serve as chaplain to the Irish Guards in France and Flanders for the duration of World War I. Wounded five times and gassed once, he won

Introduction

the Military Cross and Bar, the French *Croix de Guerre* and the Belgian *Croix de Guerre*. His commanding officer, who went on to become Field Marshal Earl Alexander of Tunis, described Father Browne as 'the bravest man I ever met'.

During 1919 and 1920 he was stationed with the army of occupation at Cologne. Then he returned to Dublin and continued to teach at Belvedere College until 1923 when he became superior of Gardiner Street church. His six-year term of office was interrupted by ill-health. His lungs were deteriorating due to the wartime mustard-gas in the trenches, and he was advised to try a warmer climate. As a consequence, he spent the years 1924 and 1925 in Australia where he visited all the major cities and travelled for many miles in the outback, returning with an outstanding collection of photographs, now in print as *Father Browne's Australia*.

By February of 1926 he was back at Gardiner Street and in 1929 he was appointed to the Jesuit Retreats and Missions staff where he served for the rest of his life. His work took him to practically every parish in Ireland and to many in England, Scotland and Wales. He took his camera wherever he went and became more than just a happy snapper. The Kodak Company was so impressed by his work that it gave him a free supply of film for life. Many public and private organisations – including the British Museum, the Irish National Museum and the Church of England Governing Body – commissioned him to take photographs of historic interest.

Father Browne also made several 16mm movies, including one of Dublin's Eucharistic Congress, which was attended by over two million people, in 1932. The Department of Agriculture, the Forestry Commission and the Garda Síochána – the Irish police force – were among the public bodies that asked him to film their work.

In 1926 he became vice-president of Ireland's first Salon of Photography – a post he retained until it was disbanded in 1939 – and won many awards for his own still photography. From 1925 to 1960, he was a member of both the Irish Photographic Society and the Dublin Camera Club, for both of which he acted as adjudicator. He died in 1960 and was buried in Glasnevin Cemetery in Dublin, where he shares a grave with the Jesuit poet, Gerard Manley Hopkins.

During Father Browne's long life quite a revolution took place in the realm of transportation. Ocean liners were his first love and his post-*Titanic* photographs have appeared in the book *Ships and Shipping* (Wolfhound Press, 2000). The development of the internal combustion engine during his lifetime led to his taking hundreds of pictures of cars, lorries and motorcycles. Frequently he borrowed friends' motors, ranging from the old Ford model T to the sporty Riley. When in England he was often chauffeur-driven in Lady Ashburnham's Austin Princess. No doubt a book on road transportation will appear in due course as will a book of his aircraft and aerial photography. Father Browne learned to fly airplanes and made many friends in the Irish Airforce at Baldonnell (now Casement) Aerodrome. His photographs record the early days of the new airports at Collinstown (Dublin) and Rineanna (Shannon), the new Aer Lingus Douglas aircraft and the Pan-American Clippers.

But, after ships, his next preference was for trains – now reflected in this second volume of his transportation photographs to be published. Thousands of books have been published about railways, including some excellent ones on Ireland's trains. However, a quick flick through this volume will show you that it is different on several counts, reflecting the unique qualities of a master photographer at work.

Among the distinguishing characteristics of these railway photographs are the following. First, the pictures were taken by one of Ireland's greatest photographers and they have an inherent artistic merit. Secondly, there is an emphasis on *people* that is usually lacking. Railwaymen involved in their various tasks and passengers arriving, departing, changing trains or dining in them do not normally feature prominently in railway books. Thirdly, although most

of the photographs were taken in Europe's offshore islands, this book has the added pleasure of including some trains from as far afield as Suez and Sydney. Fourthly, trains books rarely show photographs of accidents: this one shows three, one of which was serious. Fifthly, Father Browne had special permission to board and photograph the 'Travelling Post Office' en route between Dublin and Cork. A letter survives, from the Great Southern Railways, granting him leave to take these pictures and to publish them. They are unique in showing every aspect of the TPO operation.

Most of the photographs in this book were taken in Ireland during the 1930s. As mentioned above, Father Browne's pastoral work took him all over the country and he usually travelled by rail. At that time Ireland had a lot more railway lines than it has today. In the thirties he would have been able to travel by train to places like Omagh, Enniskillen, Bantry, Letterkenny and Cavan. Today he would have to go by road.

In the 1930s there were very few towns in Ireland further than ten miles from the nearest railway station. Three thousand four hundred miles of track covered the country and these had been laid down by many different companies. By 1925 the Great Southern had taken over all the companies whose lines lay wholly within the Republic of Ireland. Father Browne photographed all of these as well as the Great Northern Railway, which ran, with branches, from Dublin to Belfast and Derry. He was also on the Northern Counties Railway – which joined those two cities via Coleraine. As will be seen later, he travelled on many of Ireland's narrow-gauge railways as well.

In England there were similar amalgamations of the railway companies and by Father Browne's time only four major ones remained. His travels took him on all four of these. On his way to board the *Titanic* in 1912, he went from London to Southampton on the London & South Western Railway which was merged into the Southern Railway (SR) in 1923; frequently he travelled from London to Holyhead on the London Midland and Scottish Railway (LMS) and to Liverpool on the London & North Eastern Railway (LNER); occasionally, especially if he was heading home to Cork, he would take the Great Western Railway (GWR) from London to Fishguard.

Overall, he took many hundreds of photographs of railways and many favourites have had to be omitted in making the selection for this book. As you can see from the table of contents, I have divided the pictures into ten chapters and have kept technical detail to a minimum. For providing this technical information, I wish to thank Fr Dermot Mansfield SJ, a member of the Irish Railway Record Society, for his invaluable help.

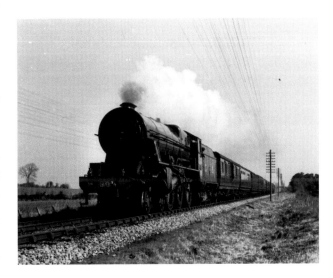

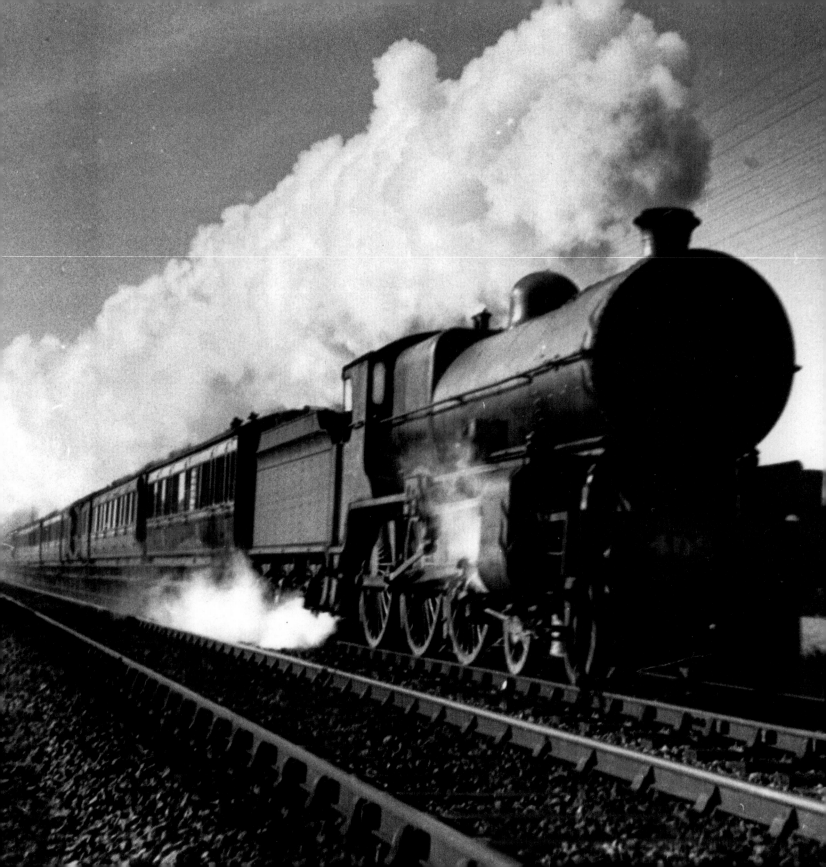

Trains

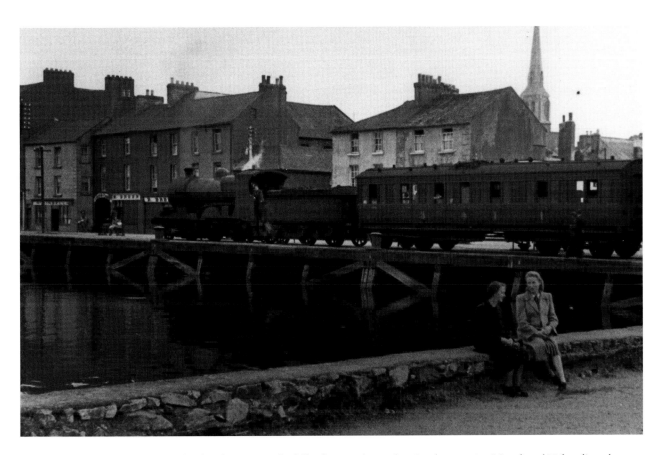

Opposite: A favourite photograph of Father Browne's, full of atmosphere, showing locomotive Number 409 heading the Cork-Dublin morning train in early CIÉ days. Taken in Co Laois (1944).

Above: On the Quay, Wexford (1946).

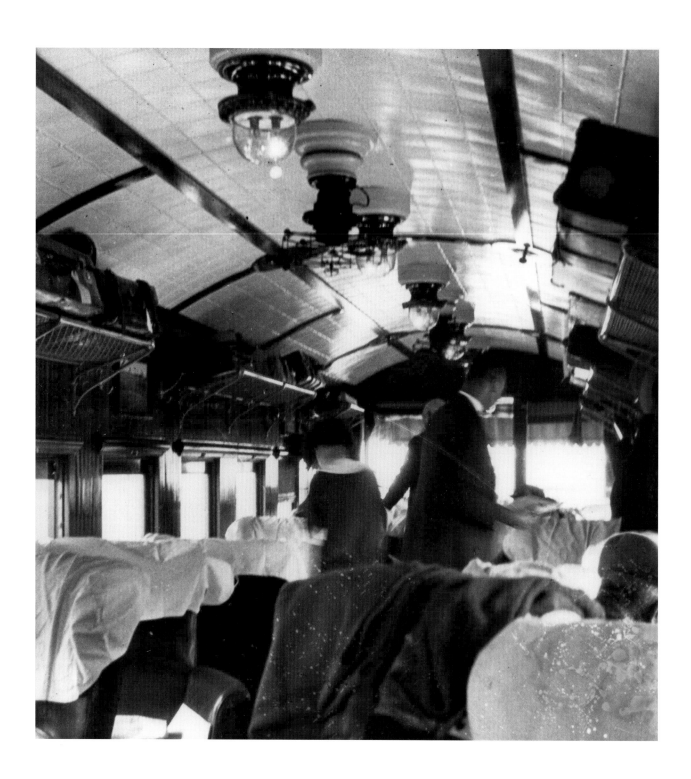

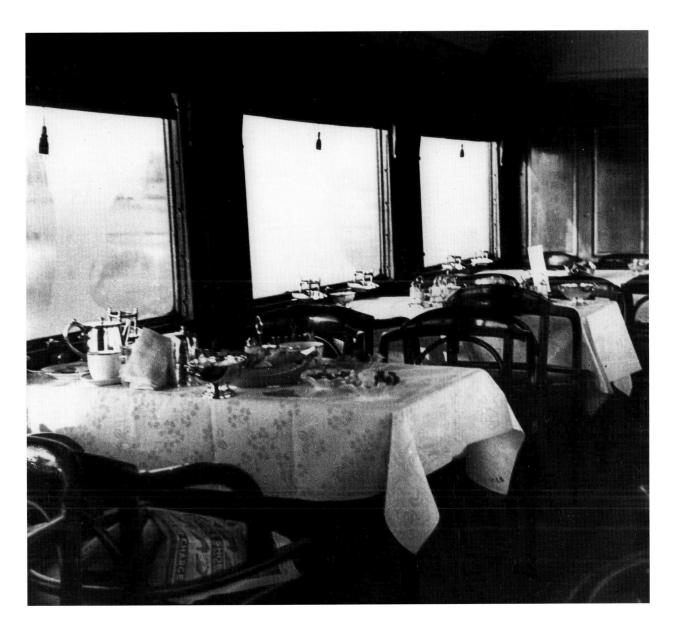

Opposite: Interior of carriage on the Sydney-Brisbane Express (1925).

Above: Dining-car of the Euston-Holyhead boat-train (1933).

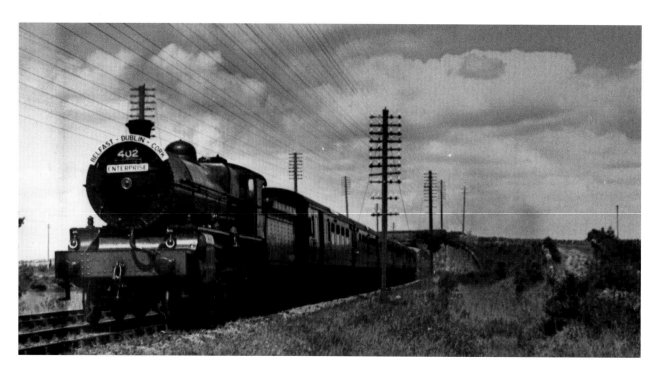

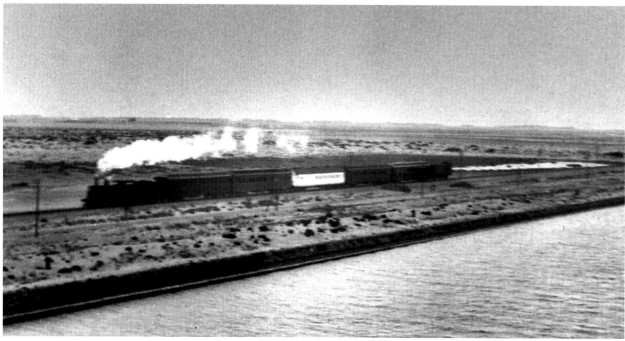

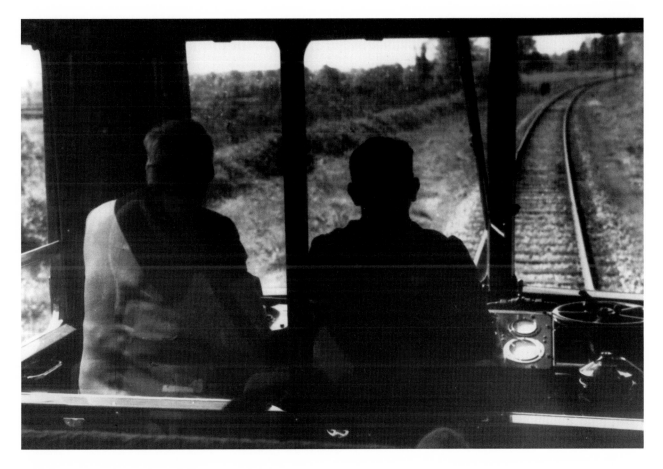

Opposite top: The Belfast-Dubin-Cork 'Enterprise' Express passing through Co Laois near Portarlington (1951). The through journey covered 281 miles but the Dublin-Cork stretch lasted only from 1950 to 1953. The locomotive photographed here, Number 402, held the speed record on the line, having worked a special train (for the first US Ambassador to the Irish Free State) from Cork to Dublin in 2 hours 27 minutes, in March 1934.

Opposite bottom: Egyptian train running alongside the Suez Canal (1926).

Above: A view of the driving compartment of one of the new diesel railcar sets near Abbeyleix, Co Laois (1953). First class passengers had a good view forward from behind the driver in these trains.

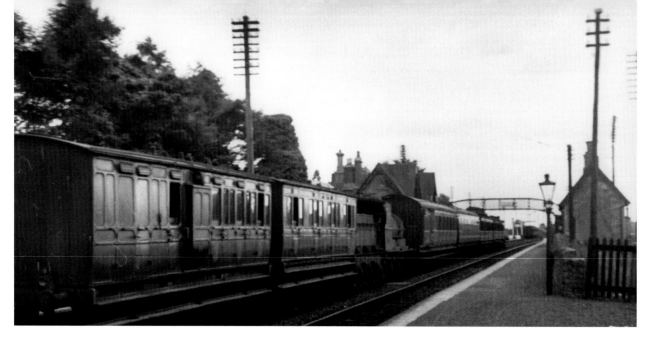

Two trains alongside the down platform at Portlaoise (1940). The train in front will most likely soon depart along the Cork mainline, while the one behind will set off along the Abbeyleix and Kilkenny branchline.

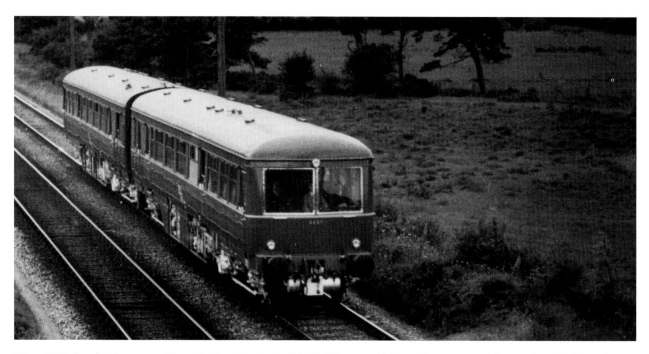

New AEC diesel railcar set at Carne Bridge, Co Laois (1953). These could be made up to an eight-coach train formation, and, followed a few years later by diesel locomotive hauled trains, heralded the end of steam traction on the CIÉ system.

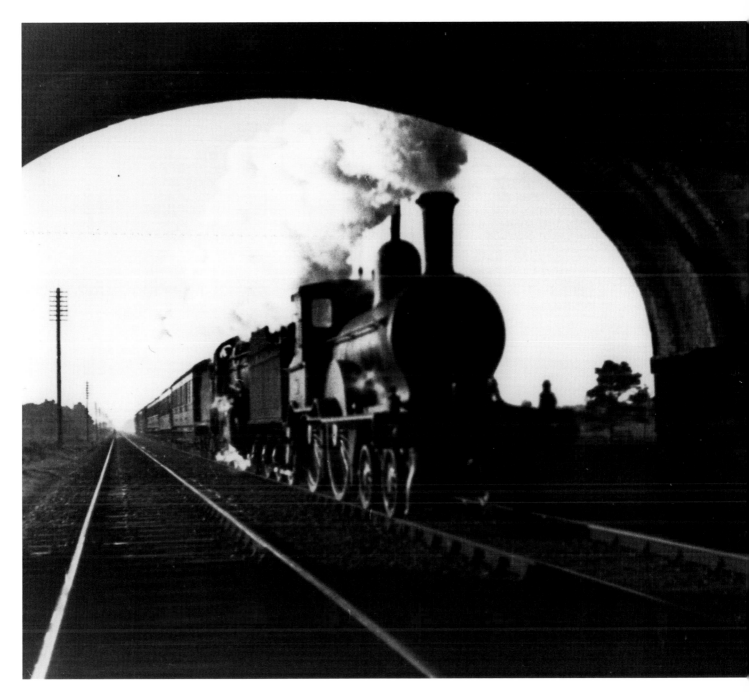

Double-headed train approaching Carne Bridge, Co Laois (1930).

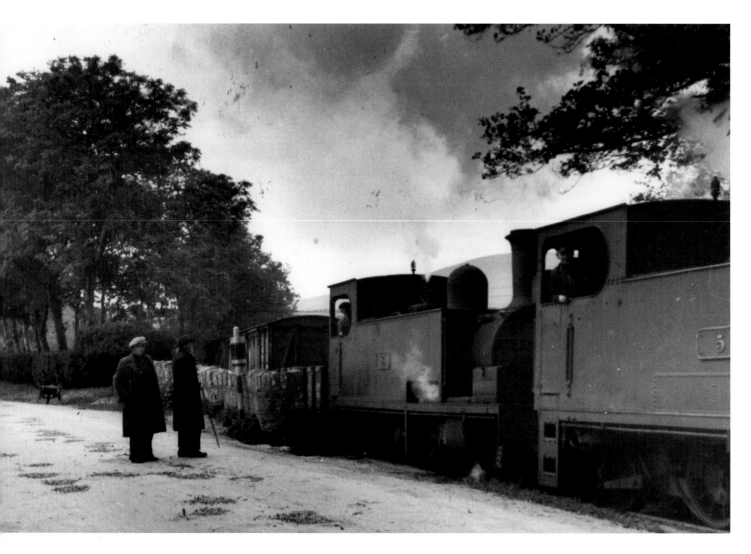

Two locomotives head the Tralee-Dingle train alongside the road at Annascaul, Co Kerry (1943). The railway specialised in carrying freight and cattle.

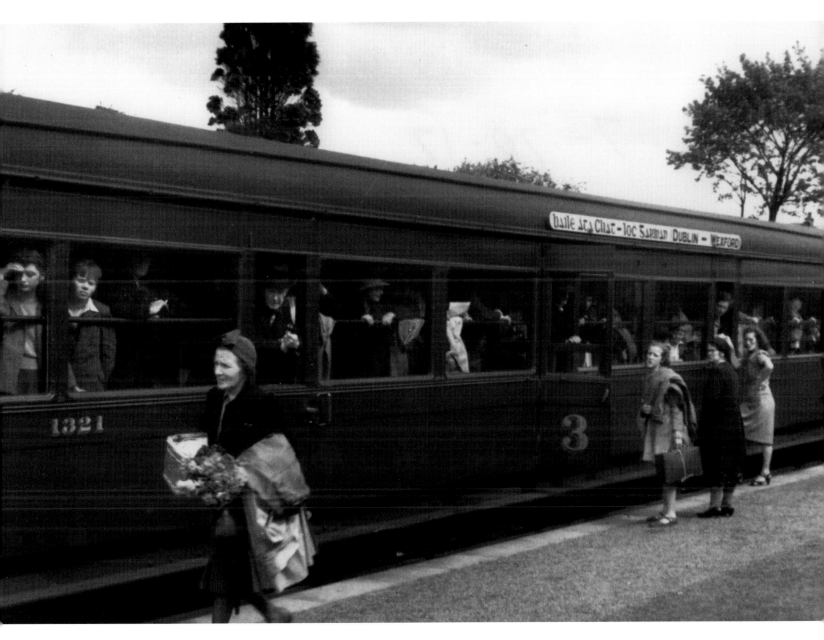

The Wexford train at Sydney Parade, Dublin (1940).

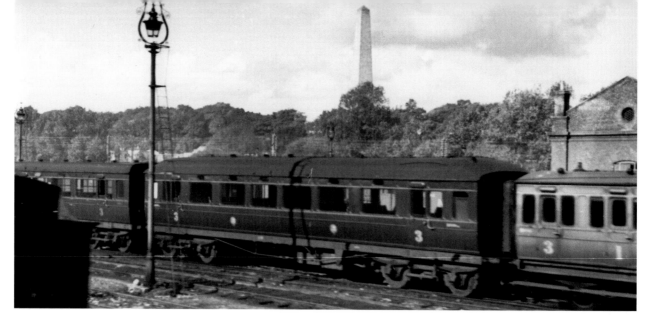

Third-class coaches at Broadstone, Dublin (1930). This station was the former terminus of the old Midland Great Western Railway. No more imposing third-class coach ever ran on an Irish railway than the one in centre view: it was built as the Royal Saloon for the Midland Great Western Railway and ended its days as an ambulance coach on pilgrimage trains to Knock in Co Mayo. The Wellington Testimonial – also visible from Kingsbridge – can be seen on the skyline.

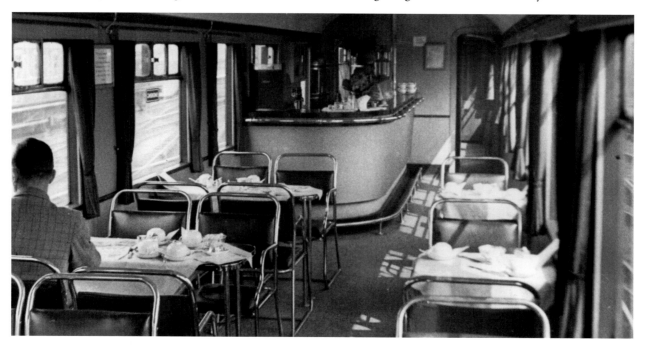

Dining-car of the London-Fishguard boat-train (1936). Taken on the Great Western Railway near Swindon, Wiltshire.

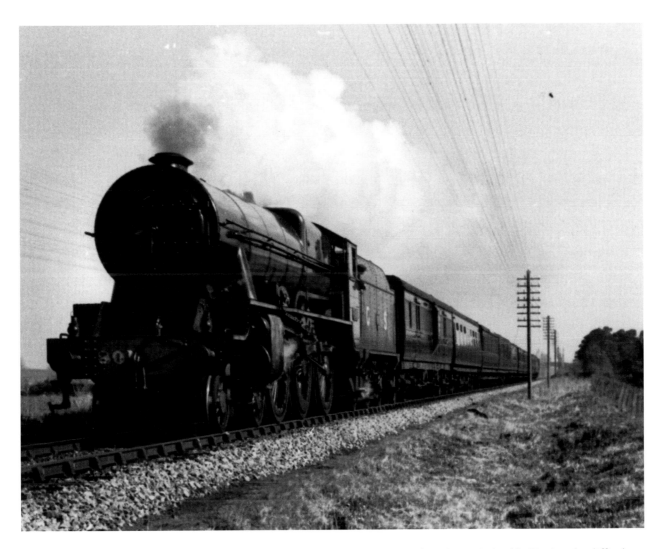

Locomotive Number 801, *Macha*, heads the daily Cork down train, Carne Bridge, Co Laois (1944). During the difficult times of the Emergency, when good coal was unavailable, engines has to steam as best they could with poor fuel substitutes. *Macha* was one of a famous trio, the others being Number 800, *Maeve*, and Number 802, *Tailte*. Built at Inchicore Works in 1939-40, they were the largest and most impressive steam locomotives to run in Ireland. *Maeve* is preserved in the Ulster Folk Museum at Cultra, Co Down.

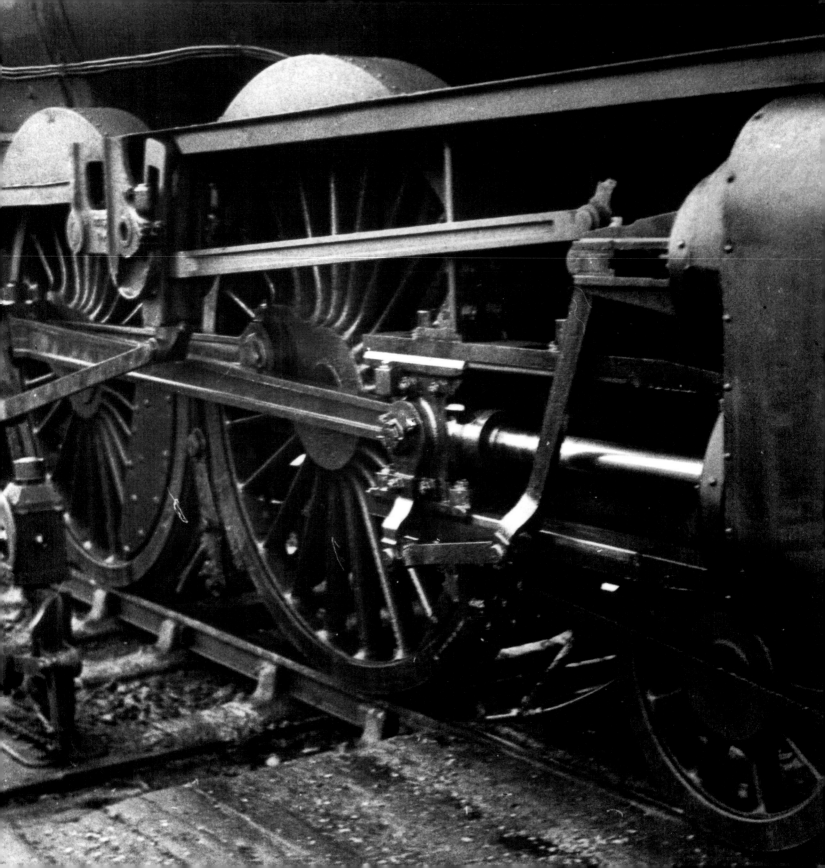

Locomotives

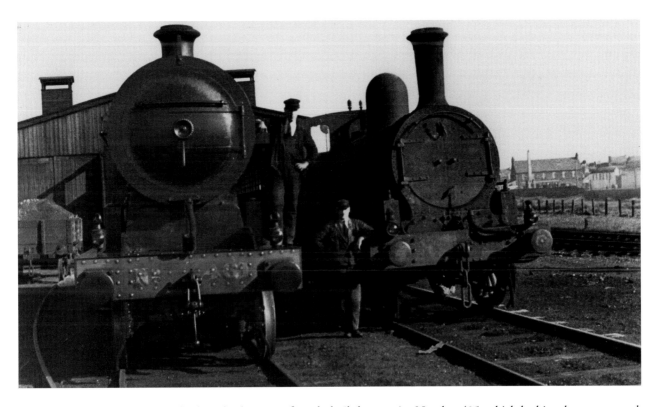

Opposite: Close-up of driving-wheels and valve-gear of newly-built locomotive Number 405, which had just been converted from four-cylinder to two-cylinder propulsion. Inchicore Works, Dublin (1933).

Above: Locomotives old and new photographed at Rosslare Harbour (1933). The larger more modern engine is Number 461, one of the two big freight engines built for the Dublin South Eastern Railway in 1922. Number 461 is happily still with us and works special trains under the auspices of the Railway Preservation Society of Ireland.

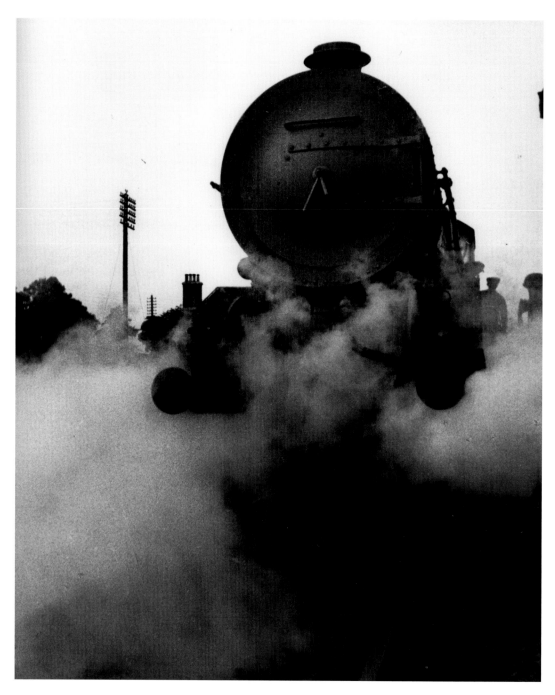

Great Southern Railways 400 class locomotive making steam at Mallow, Co Cork (1933).

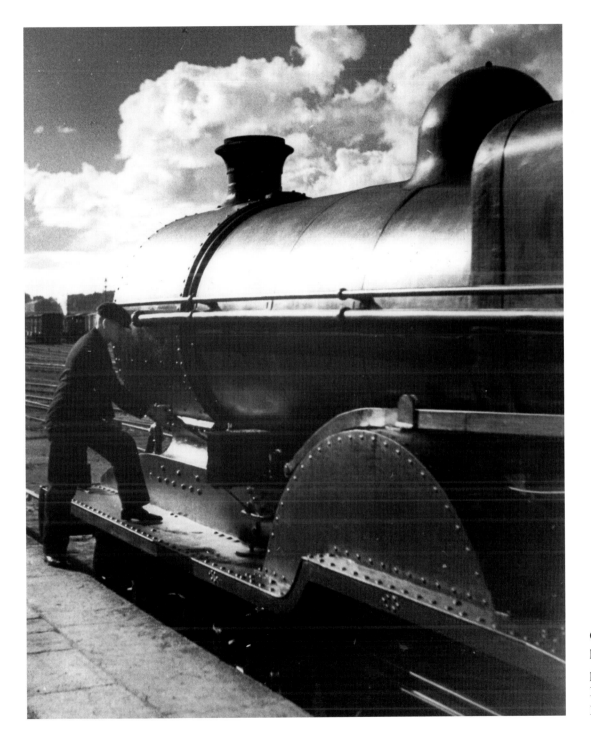

Great Southern Railways locomotive Number 403 preparing to depart from Kingsbridge Station, Dublin (1933).

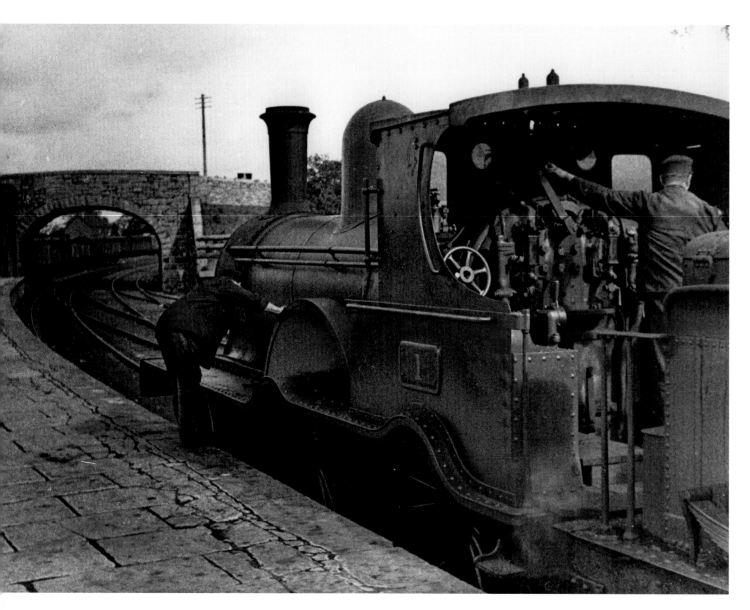

Above: Victorian locomotive Number 1 receives attention at Ennis station, Co Clare (1930). Taken on the standard-gauge main line, not the narrow-gauge West Clare Railway.

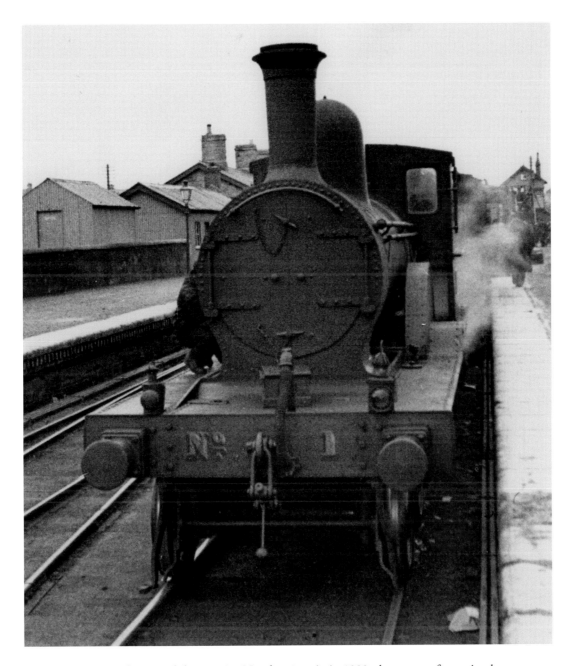

Father Browne caught up with locomotive Number 1 again in 1933, three years after seeing her at Ennis. She looks just as she did when built forty-three years earlier.

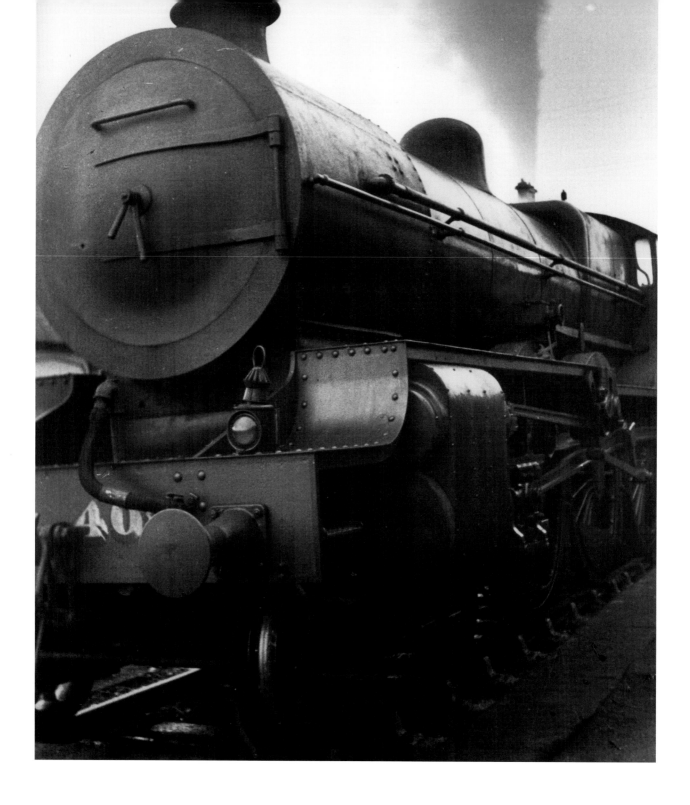

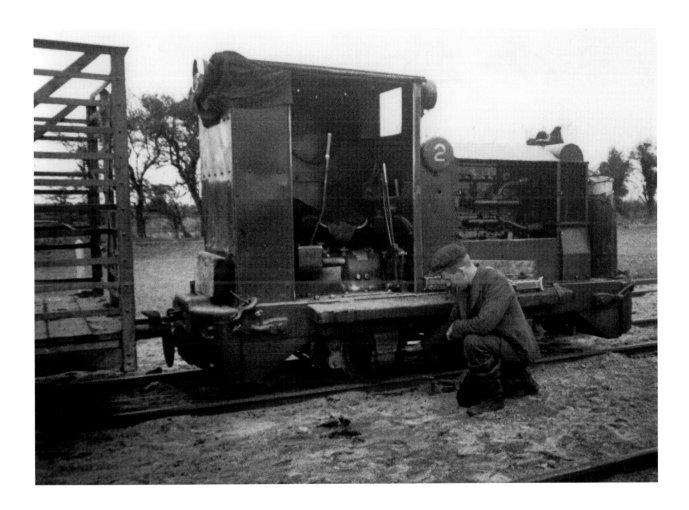

Opposite: Newly-built GSR express locomotive Number 405. Inchicore, Dublin (1933).

Above: Locomotive of bog train near Portarlington, Co Laois (1943). This is one of the early Ruston diesels used on the narrow-gauge bog railways.

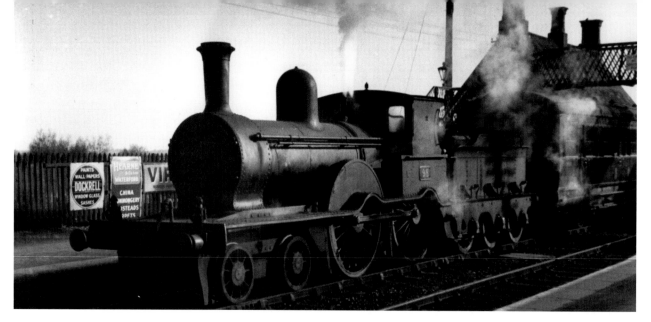

Old locomotive at Portlaoise, Co Laois (1941). The engine, Number 98, belonged to the same class as the Victorian Number 1. Dating from 1887, it continued in service until 1955.

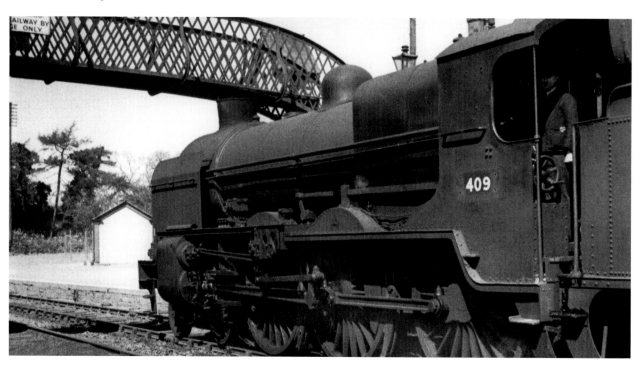

A unique portrait of express locomotive Number 409 at Portarlington, County Laois (1939). At this time it was fitted experimentally with an advanced French exhaust system which required an inelegant bucket-shaped chimney with smoke-deflecting plates alongside.

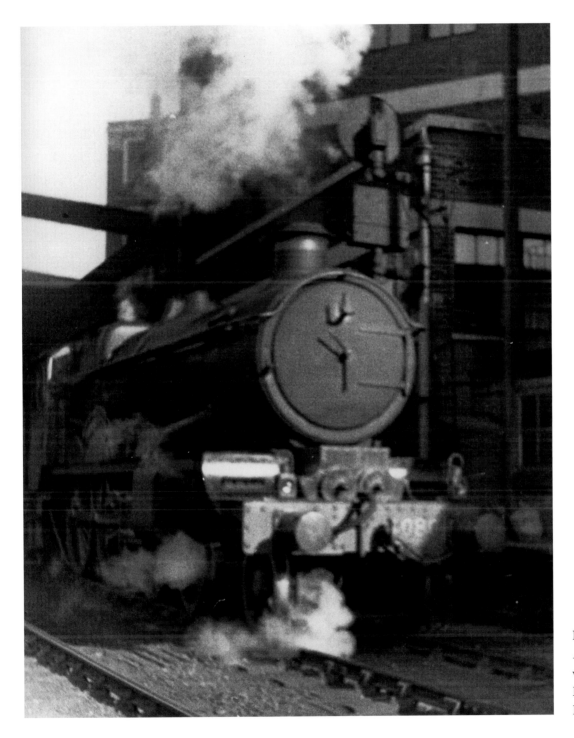

Locomotive Number 4080 *Powerham Castle* departs with a train for the west of England from Paddington, London (1931).

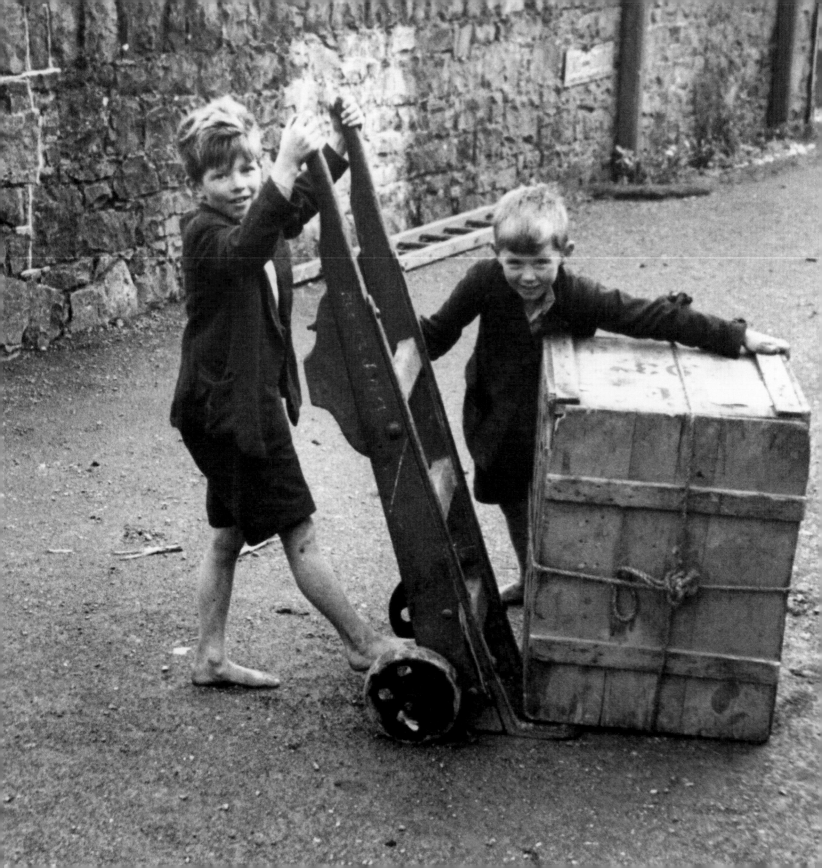

Railwaymen at Work

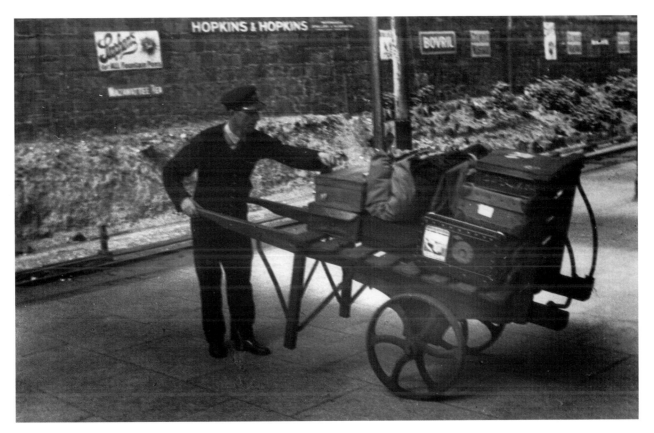

Above: Porter at Dún Laoghaire, Co Dublin (1931).

Opposite: Children playing as porters at Fethard, Co Tipperary (1938).

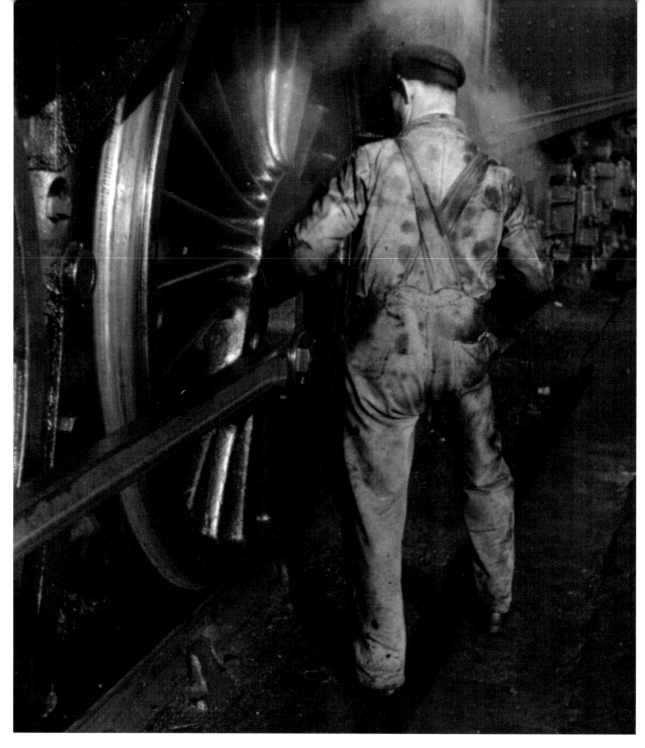

Oiling the driving motion of a large 500 class engine at Inchicore Works, Dublin (1938).

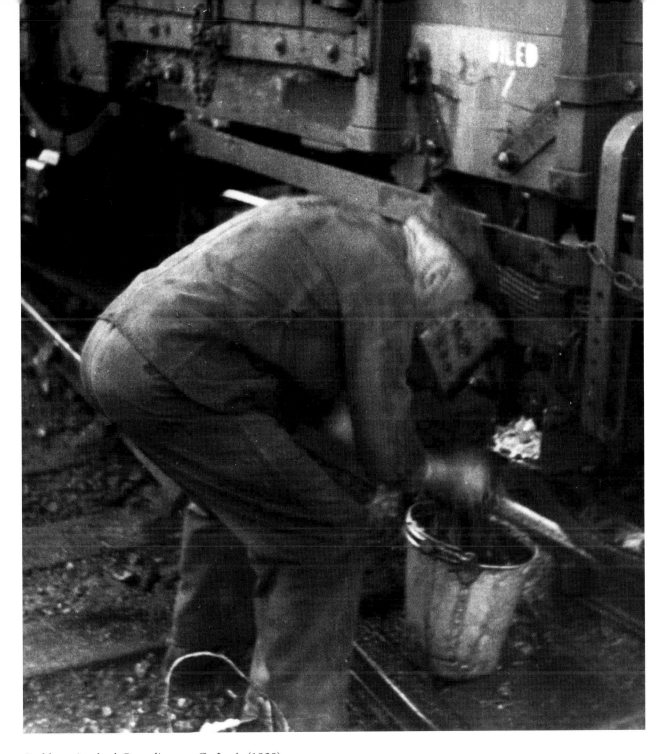

Problematic wheel, Portarlington, Co Laois (1930).

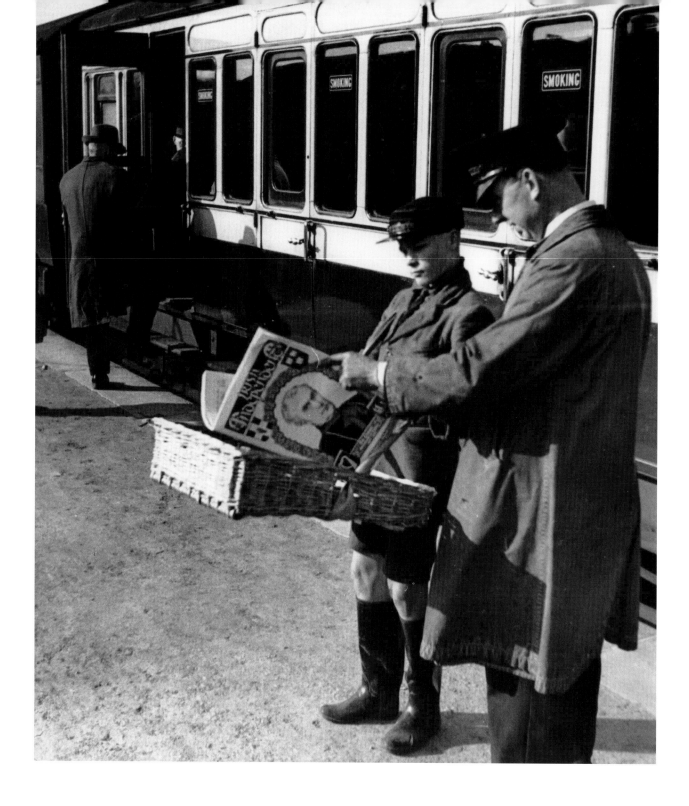

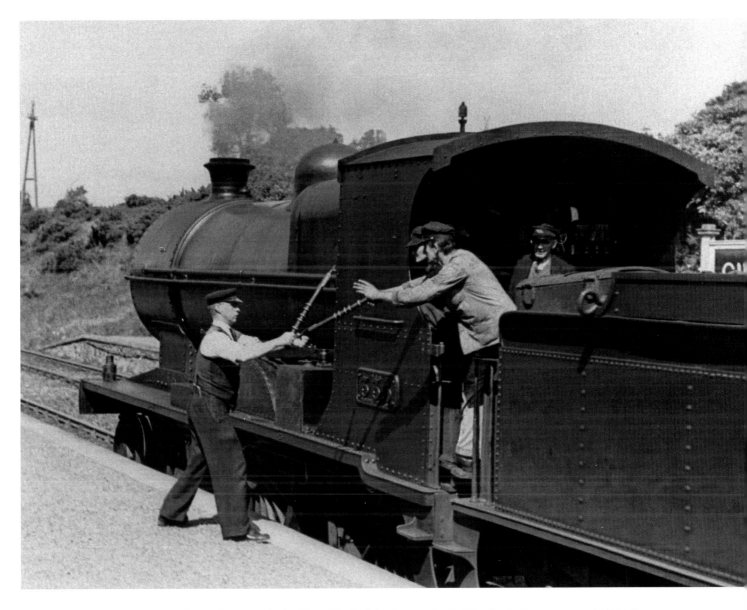

Above: Changing the 'staff' at Wexford Station on the Dublin South Eastern network (1946).

Opposite: Newsboy at Harcourt Street Station, Dublin (1930).

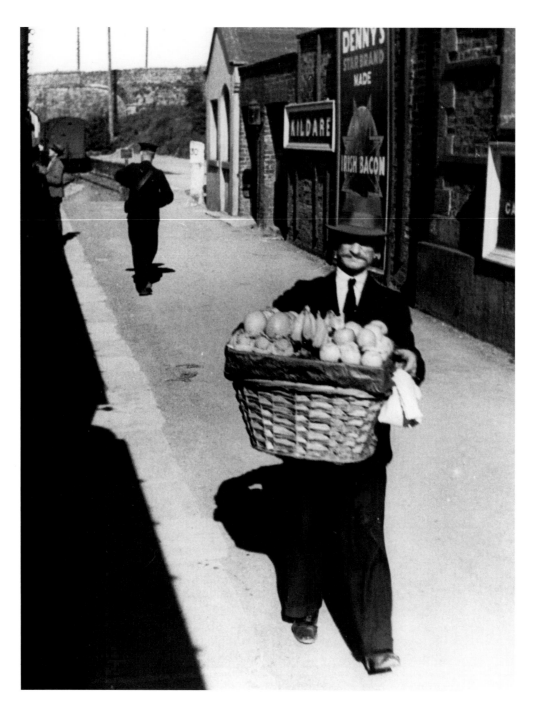

Refreshments at Kildare (1930).

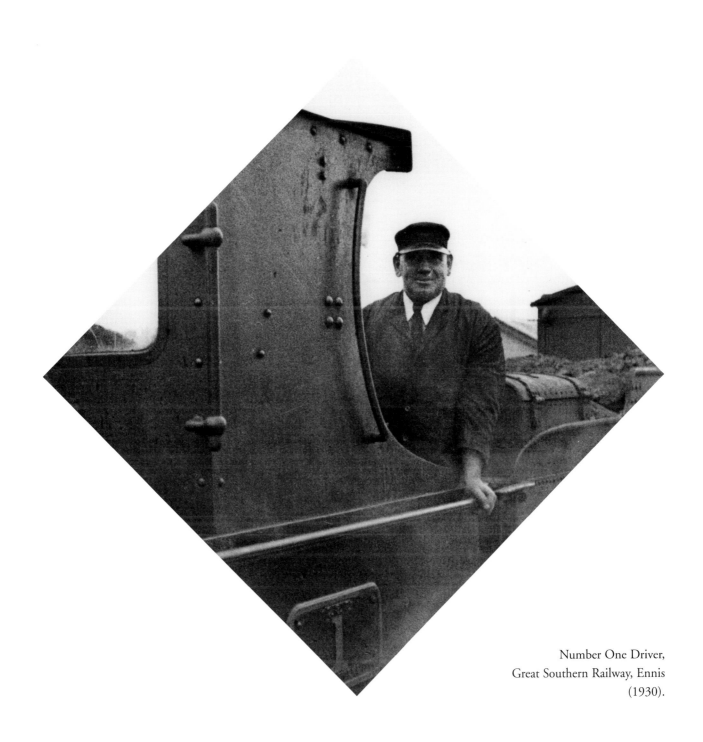

Number One Driver,
Great Southern Railway, Ennis
(1930).

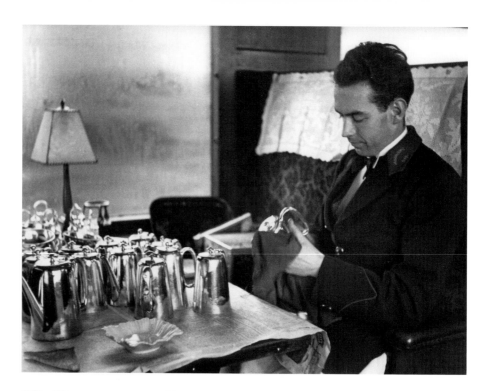

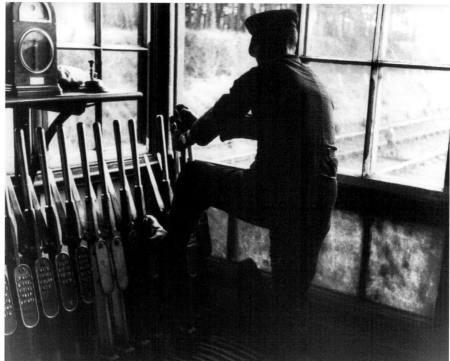

Top: Polishing the silverware on the London-Southampton train, Hampshire (1930).

Bottom: Signalmen at work, Clones, Co Monaghan (1933).

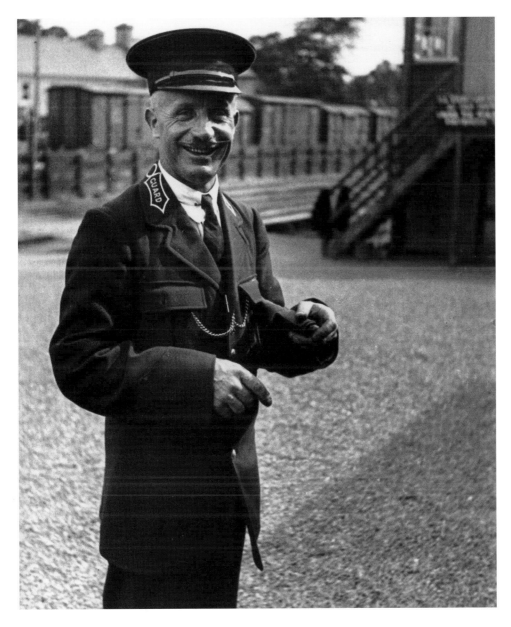

GSR guard at Mallow, Co Cork (1933).

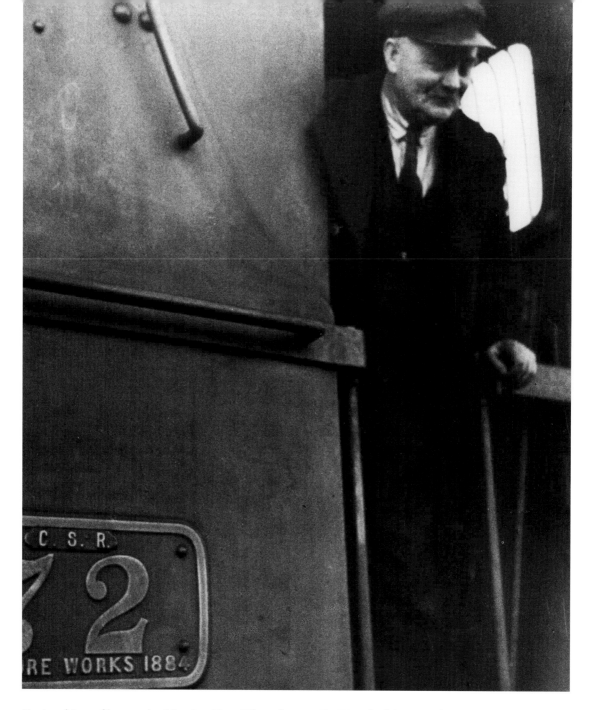

Engine driver of locomotive Number 72 at Kilmacthomas, Co Waterford (1938). The engine came from the Inchicore Works of the Great Southern Railway, Dublin. One of the last of this Victorian class of tank engine, it was withdrawn from service two years after this photograph was taken.

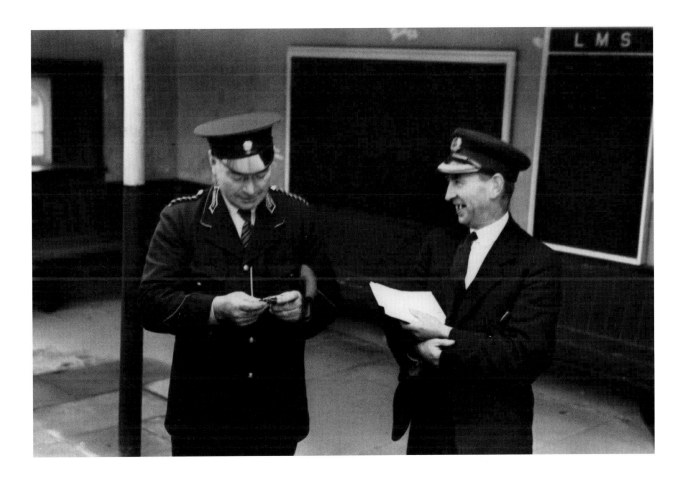

Station Master and Ticket Collector at Kiltimagh, Co Mayo (1942).

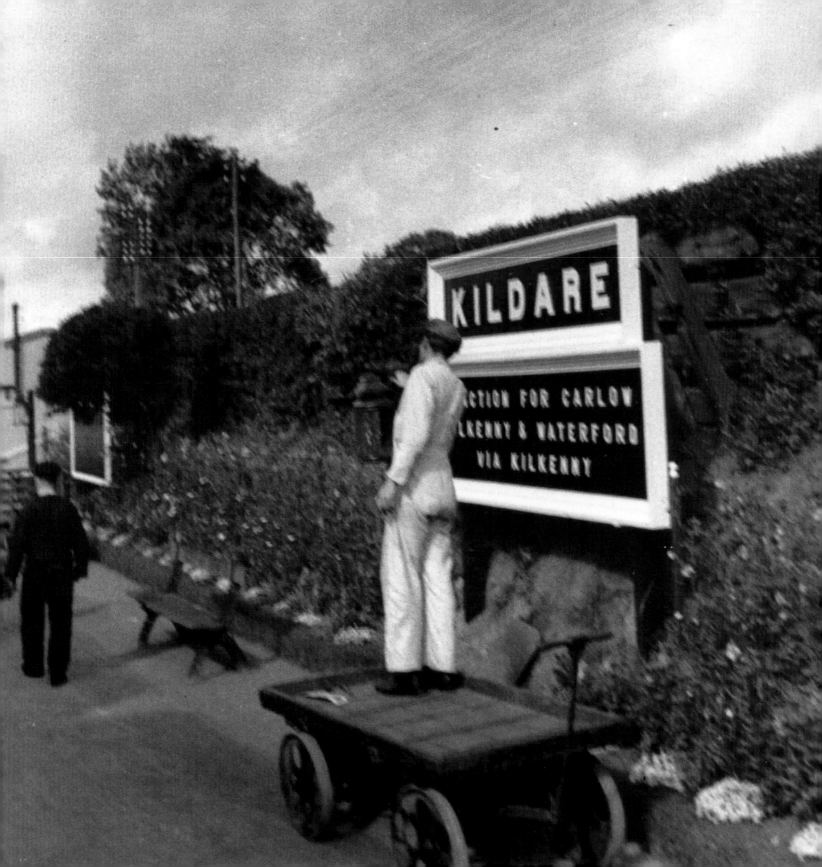

Chapter 4

Railway Stations

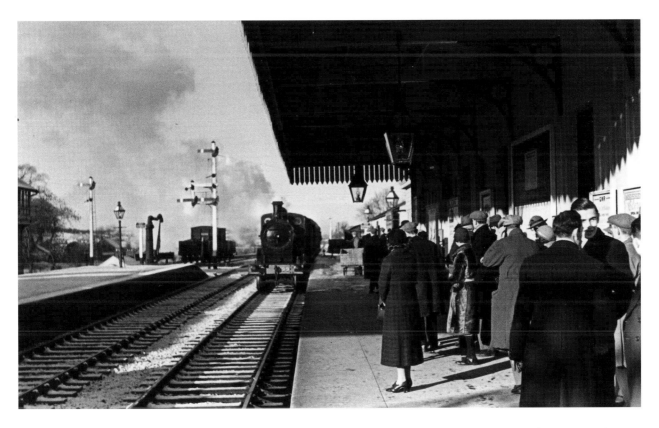

Above: Passengers at Iniskeen Station, Co Monaghan (1937). The line here closed in 1957 but during the summer of 2002 the station was converted into a private dwelling – with platform canopy retained.

Opposite: Painting the name-hoard at Kildare (1931).

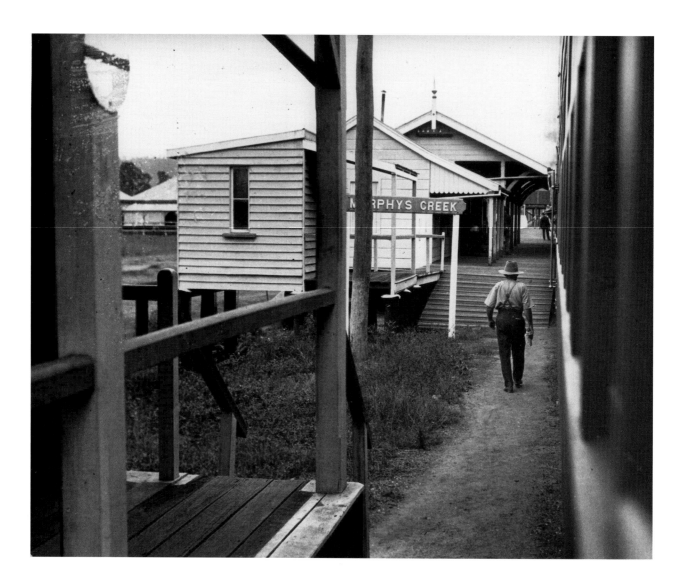

The station at Murphy's Creek, Queensland (1925).

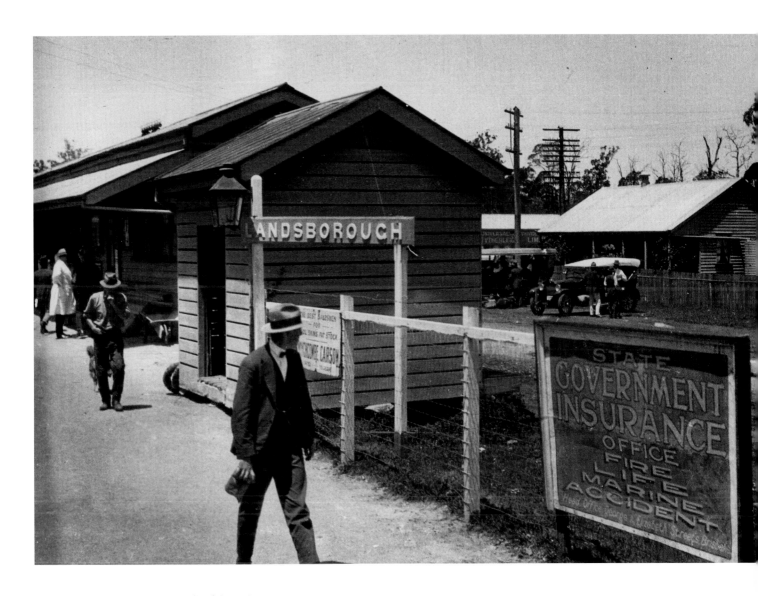

Landsborough Station, Queensland (1925).

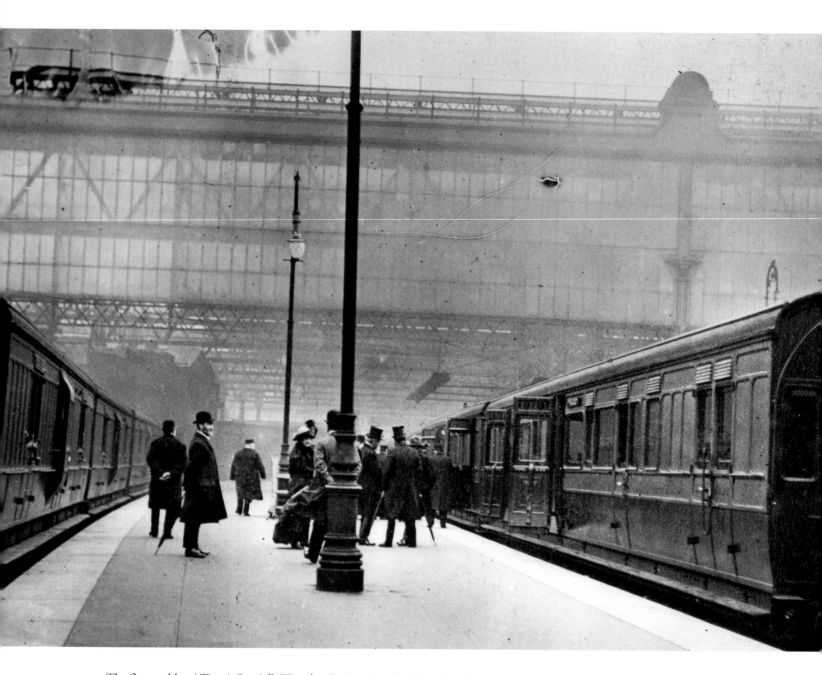

The first and last 'Titanic Special', Waterloo Station, London (1912). The London & South Western Railway was one of the companies merged into the Southern Railway (one of the 'Big Four' – the others being the GWR, the LMSR, and the LNER). The Southern Railway in turn became the Southern Region of British Railways at nationalisation in 1948.

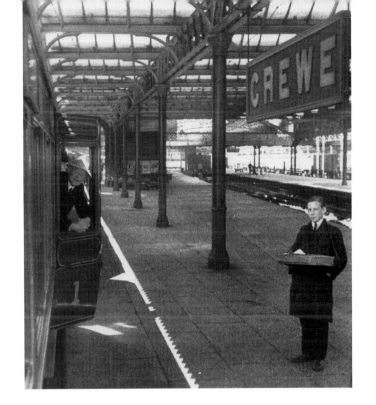

Right: Crewe, Cheshire (1933).

Below: Royal Mail at Holyhead, Wales (1936).

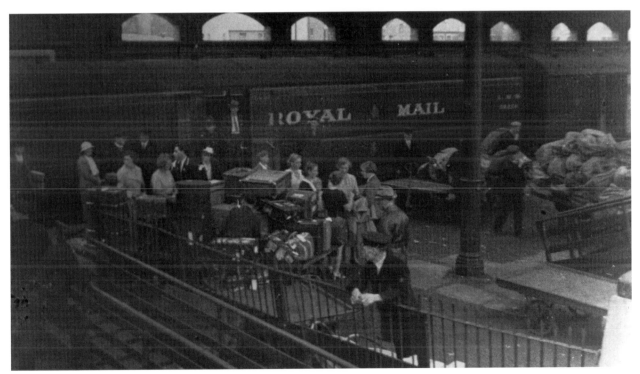

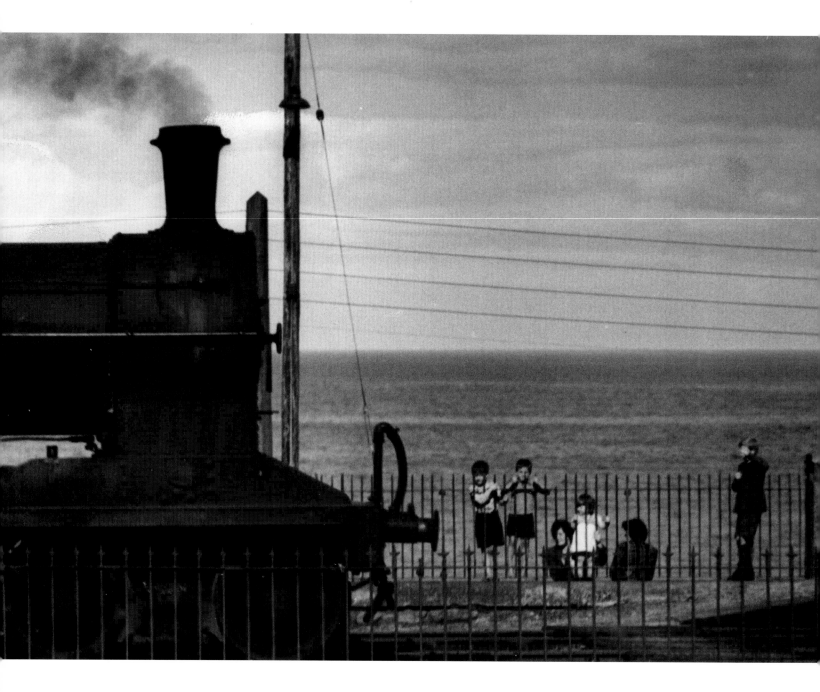

Children at Balbriggan Station, Co Dublin (1946).

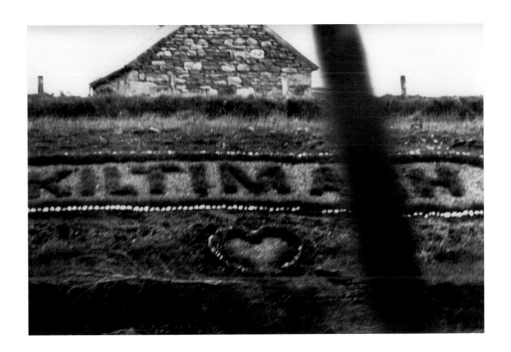

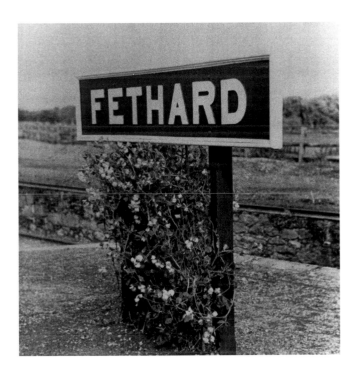

Above: Kiltimagh, Co Mayo (1942).

Left: Fethard, Co Tipperary (1938). The railway here closed for passengers in 1962.

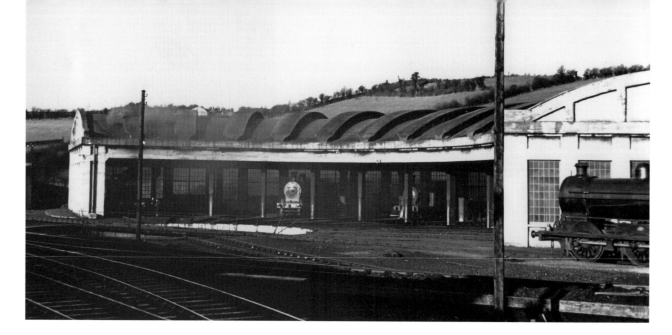

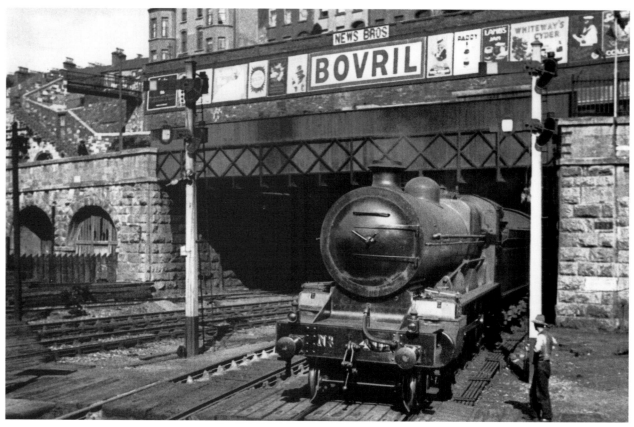

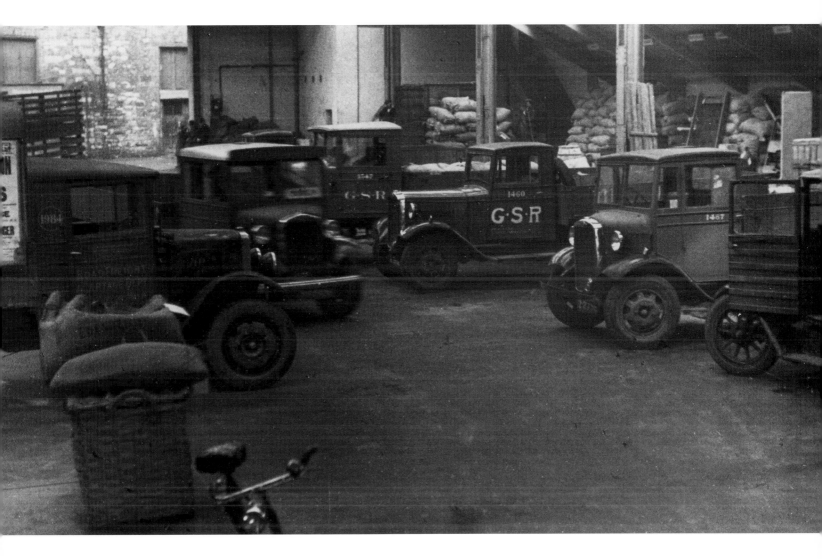

Opposite top: 'The Roundhouse' at Clones, Co Monaghan (1942). Two of these locomotive sheds were built by the GNR at a cost of £26,000 each. This one at Clones still survives, although the railway is long gone. The other, at Portadown, has been demolished.

Opposite bottom: The Dublin train arriving in Cork (1938).

Above: GSR lorries at Kingsbridge, Dublin (1930).

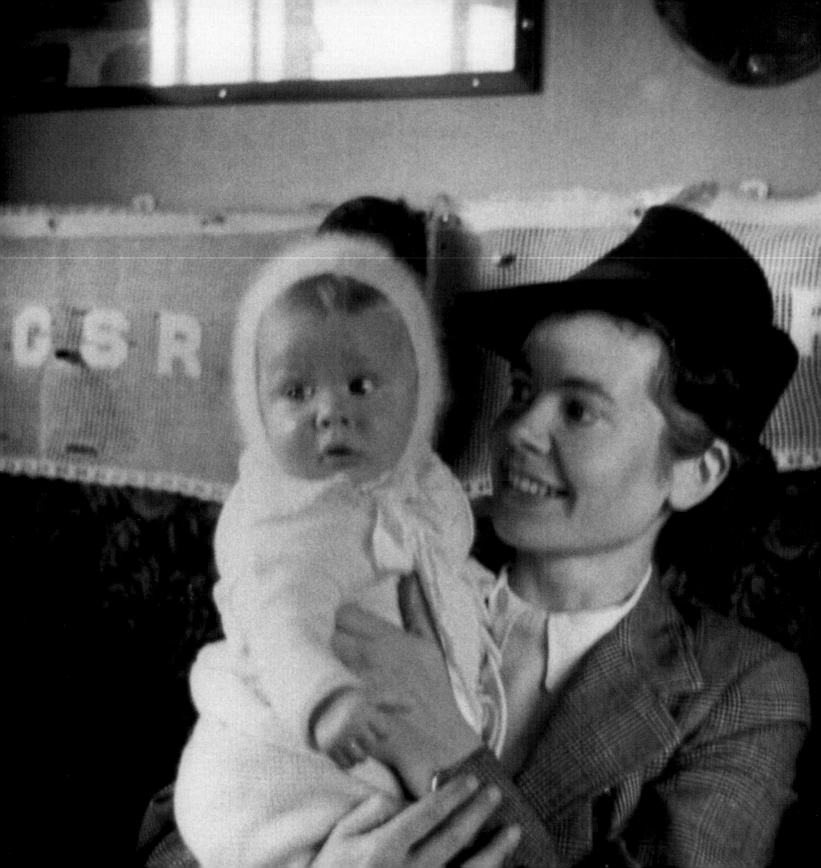

Passengers

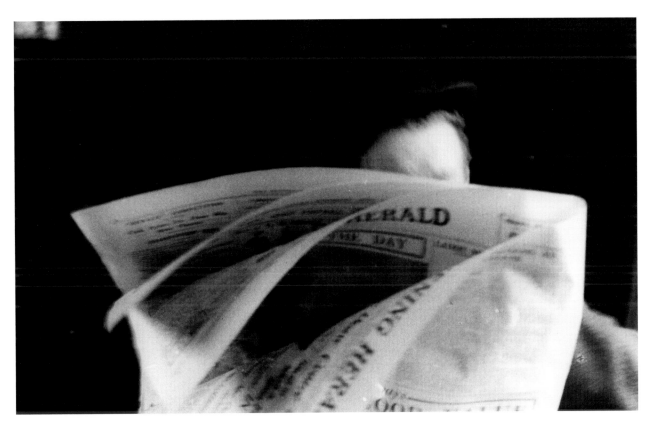

Above: Engrossed in the *Evening Herald*, Dublin-Wexford line (1933).

Opposite: Mrs Mulligan of Aughnacliffe, Granard, with her son on the Great Southern train at Edgeworthstown, Co Longford (1942).

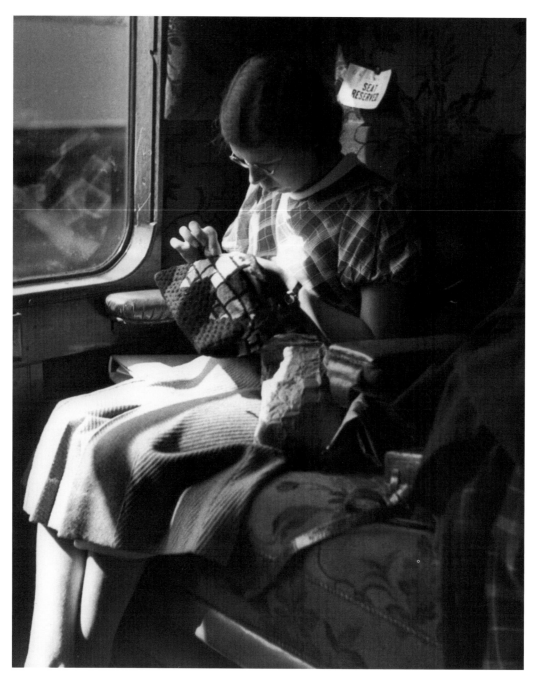

A little embroidery to while away the hours between London and Fishguard (1936). Taken on the GWR near Reading, Berkshire.

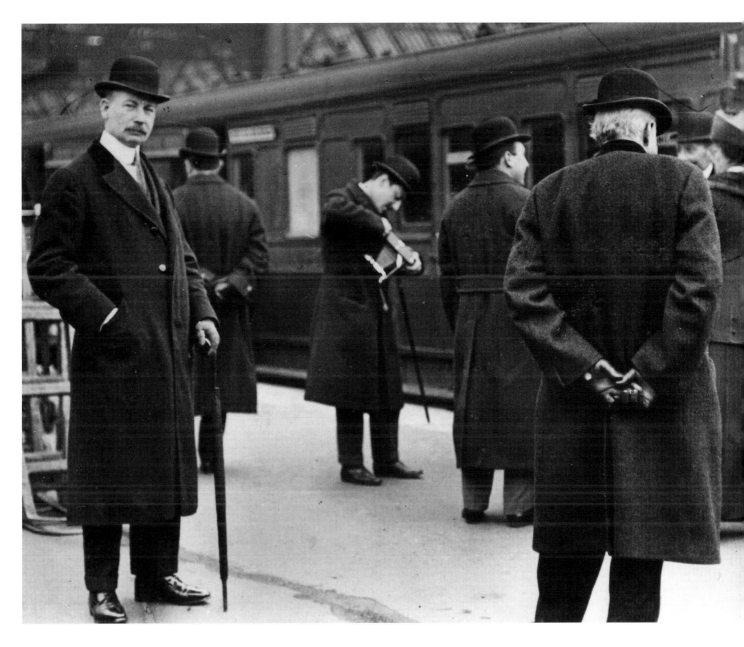

William Waldorf (later Lord) Astor photographed in front of the '*Titanic* Special' at Waterloo Station, London in 1912.

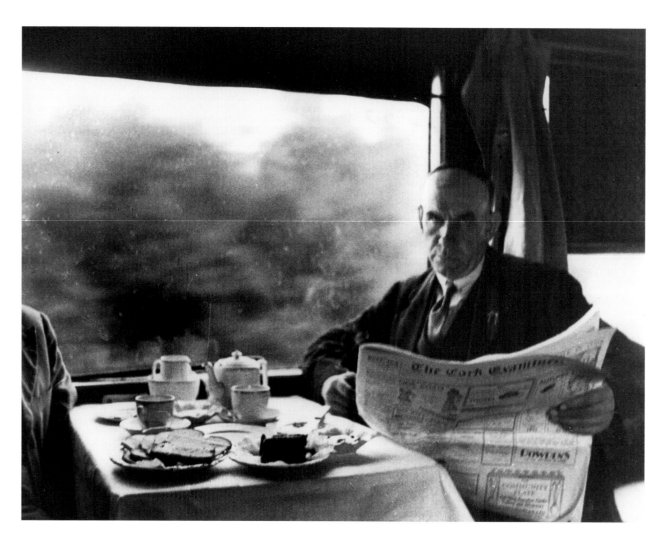

Perusing *The Cork Examiner* on the Cork-Dublin Express (1933).

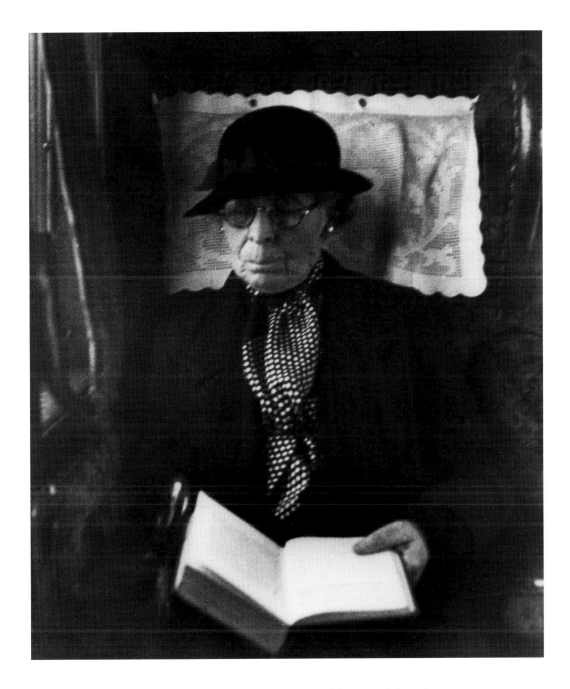

The photographer's sister, Nell Browne, travelling from Dublin to Cork (1935).

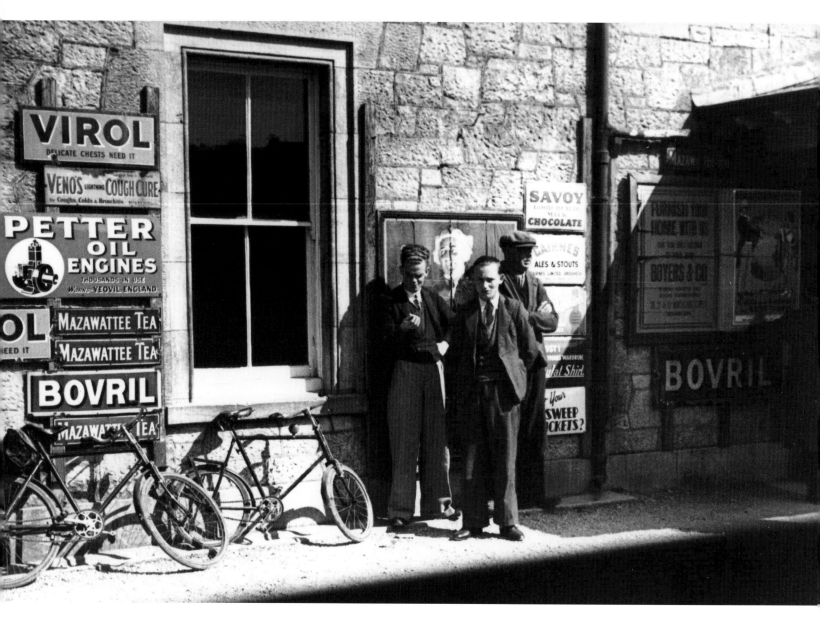

Above: On the platform at Athlone, Co Westmeath (1936).

Opposite: A tulip-seller at Great Victoria Street, Belfast (1933), with passengers arriving at the terminus of the Dublin line.

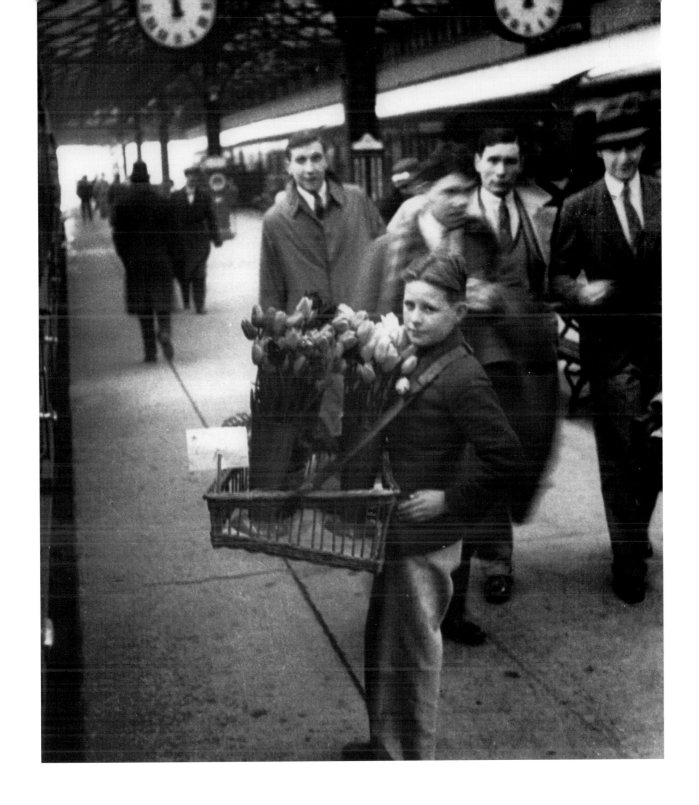

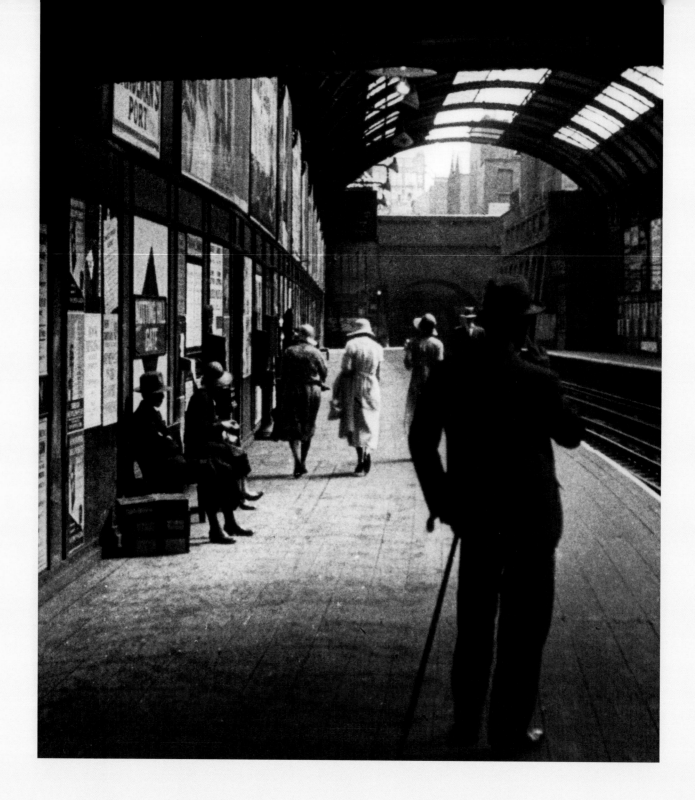

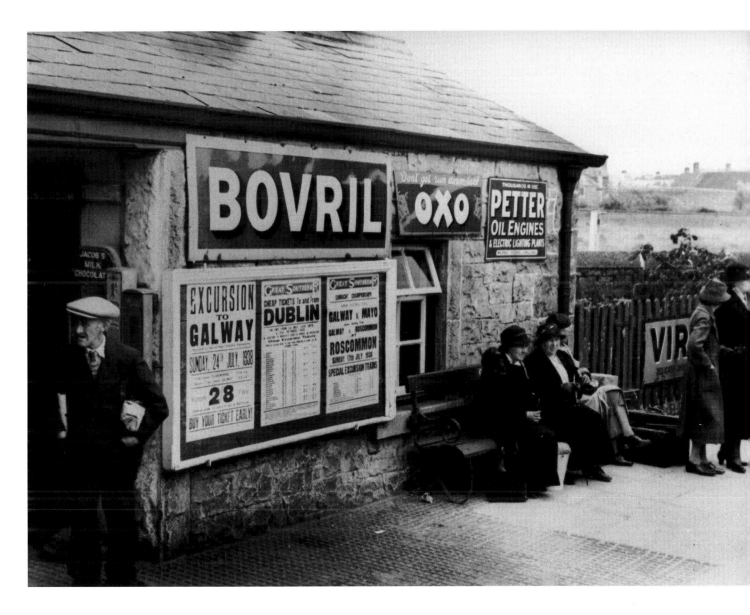

Above: Passengers at Ballymote Station, Co Sligo (1930).

Opposite: On the platform at the Glanmire Road Station, Cork (1933).

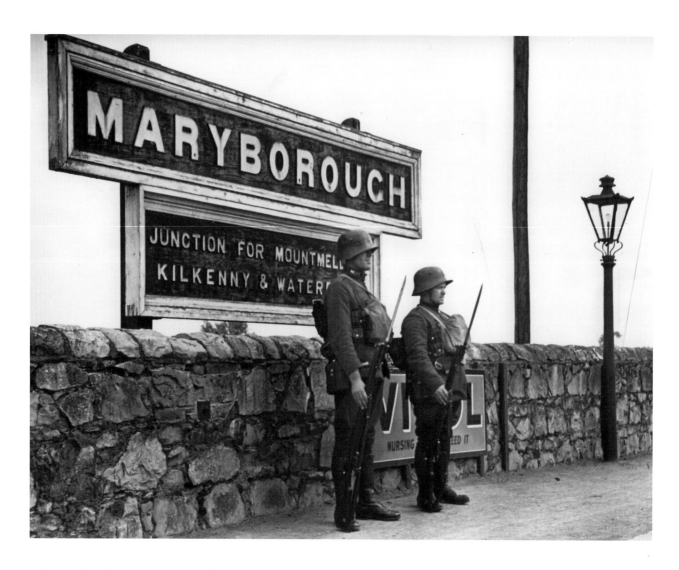

Soldiers of the Irish Army wearing German style helmets pose for Father Browne at Maryborough (now Portlaoise) Station (1940).

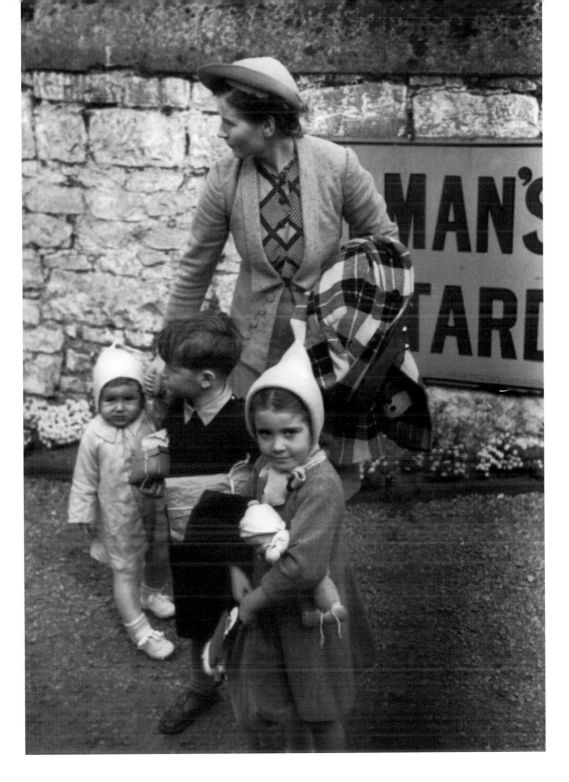

Children with their mother,
at Ballina (1941).

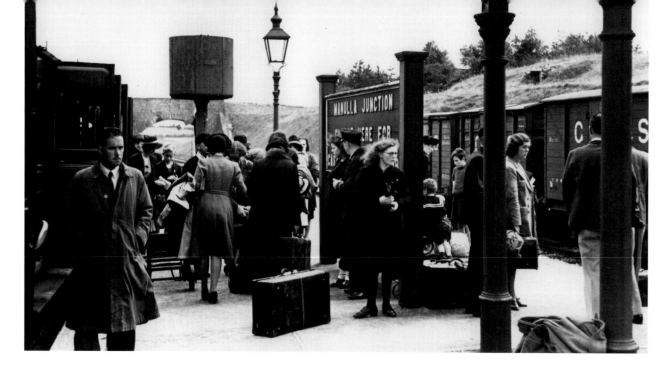

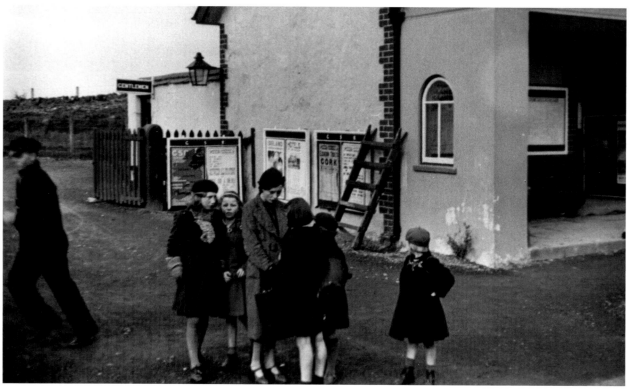

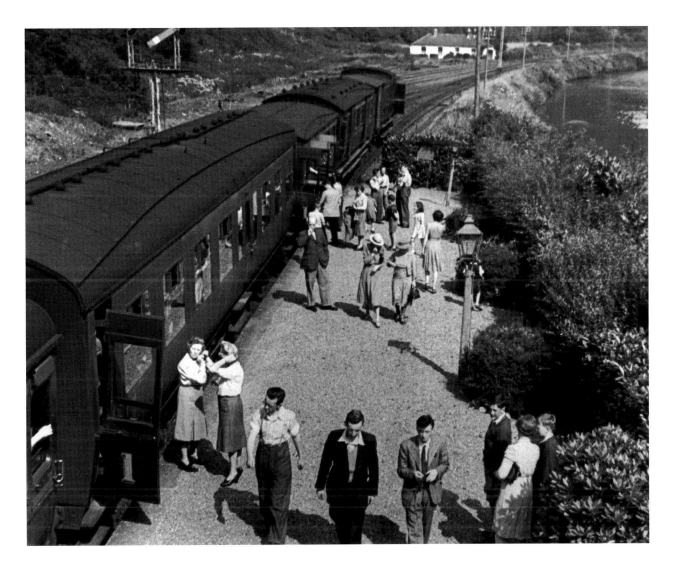

Opposite top: Passengers at Manulla Junction, Co Mayo (1941).

Opposite bottom: School children with their teacher at Foxford Station, Co Mayo (1938).

Above: A busy scene at Woodenbridge, Co Wicklow (1947).

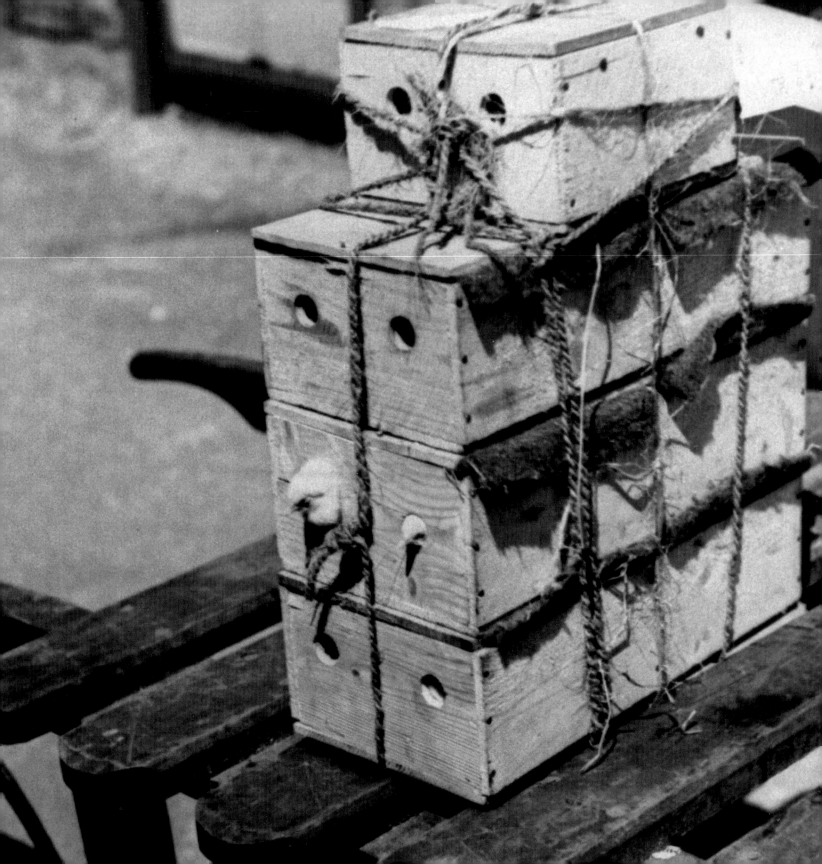

Chapter 6

Freight

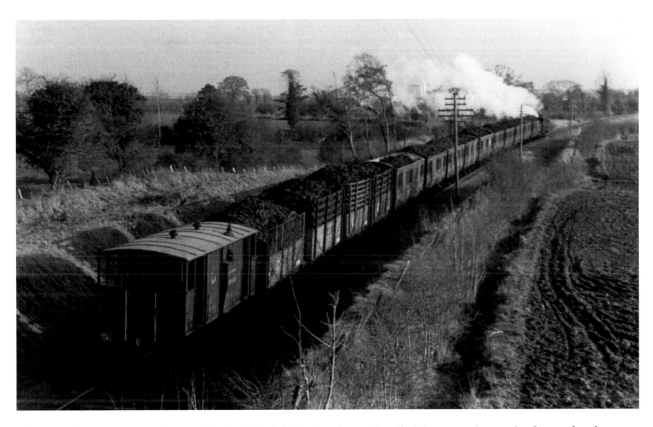

Above: Turf train near Portarlington, Co Laois (1943). During the wartime fuel shortages, thousands of tons of turf were sent from Portarlington to Dublin every week.

Opposite: Travelling fowl, Tuam, Co Galway (1942).

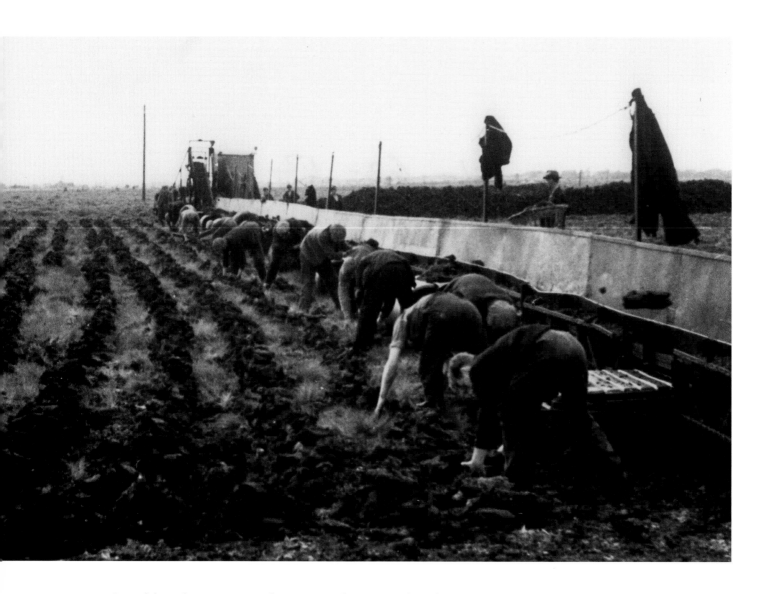

One of the early enormous Bord na Móna turf cutting machines leaving out the newly-cut turf on a form of conveyor belt which is in turn being 'footed' by the workers, Co Laois (1943). Much of this turf will be distributed by rail.

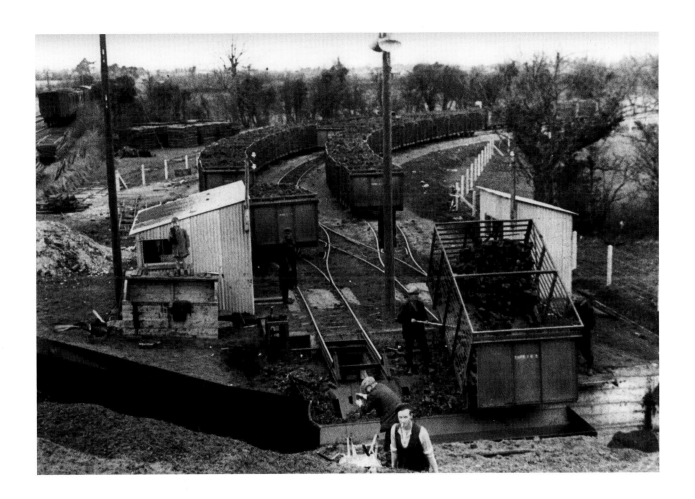

Loading turf train near Portarlington, Co Laois (1943).

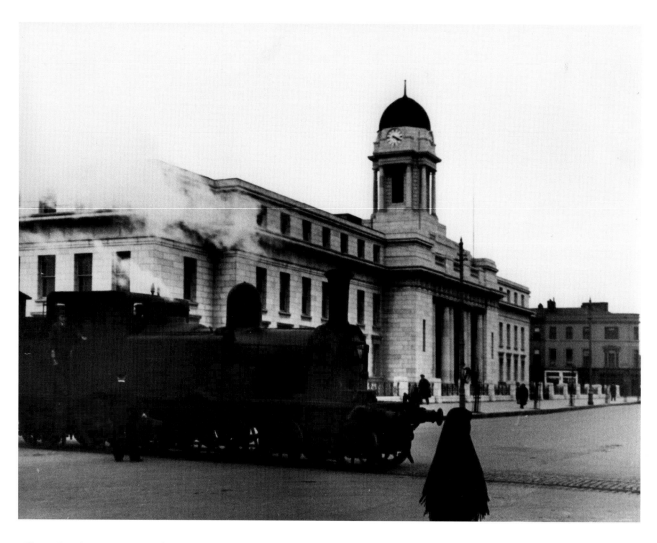

Above: Goods train passing the City Hall, Cork (1939). The train is coming from the Albert Quay Station of West Cork railways and heading for Glanmire Road, Cork's main terminus. The last train ran here in 1976.

Opposite: At the level crossing at Lincoln, England, with the cathedral in the background (1934).

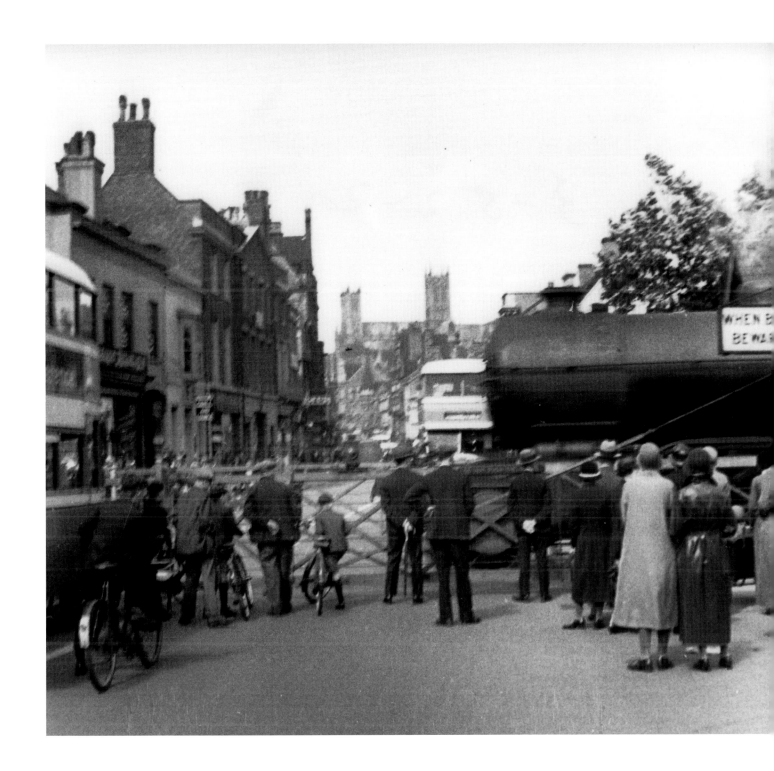

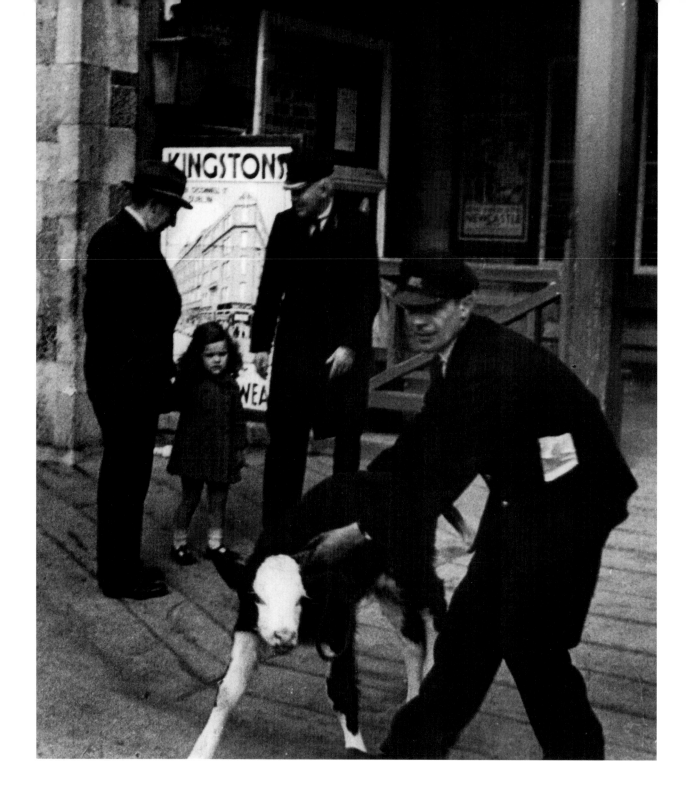

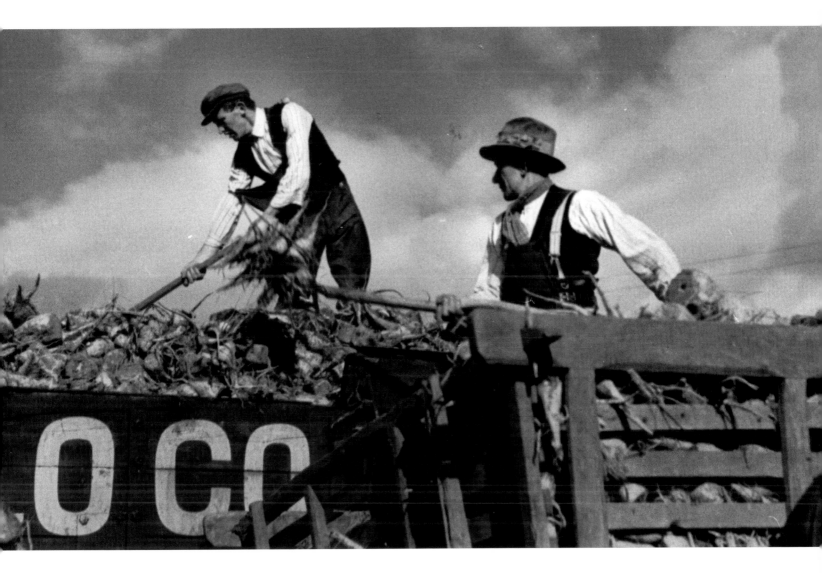

Above: Beet train at the sugar factory, Carlow (1940).

Opposite: Reluctant calf at Portarlington, Co Laois (1930).

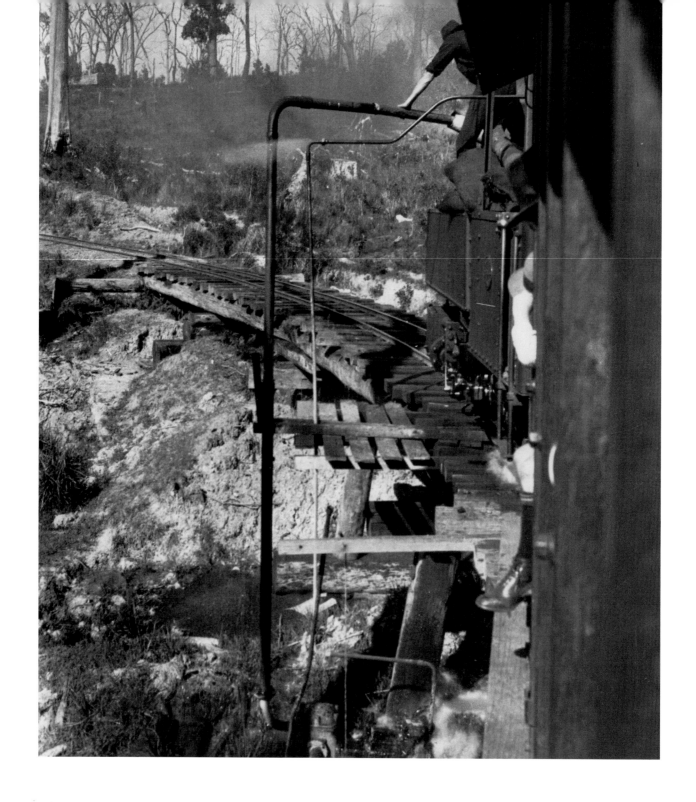

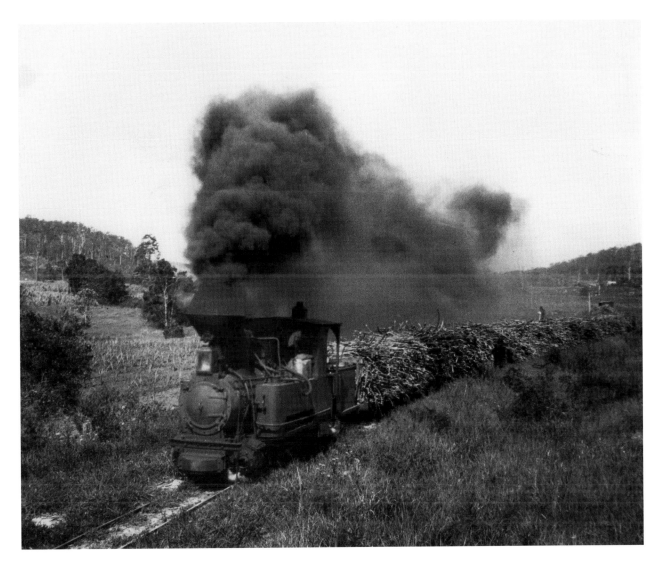

Above: Sugar train near Morstone, Queensland, Australia (1925).

Opposite: View from the footplate of a sugar train, Queensland, Australia (1925).

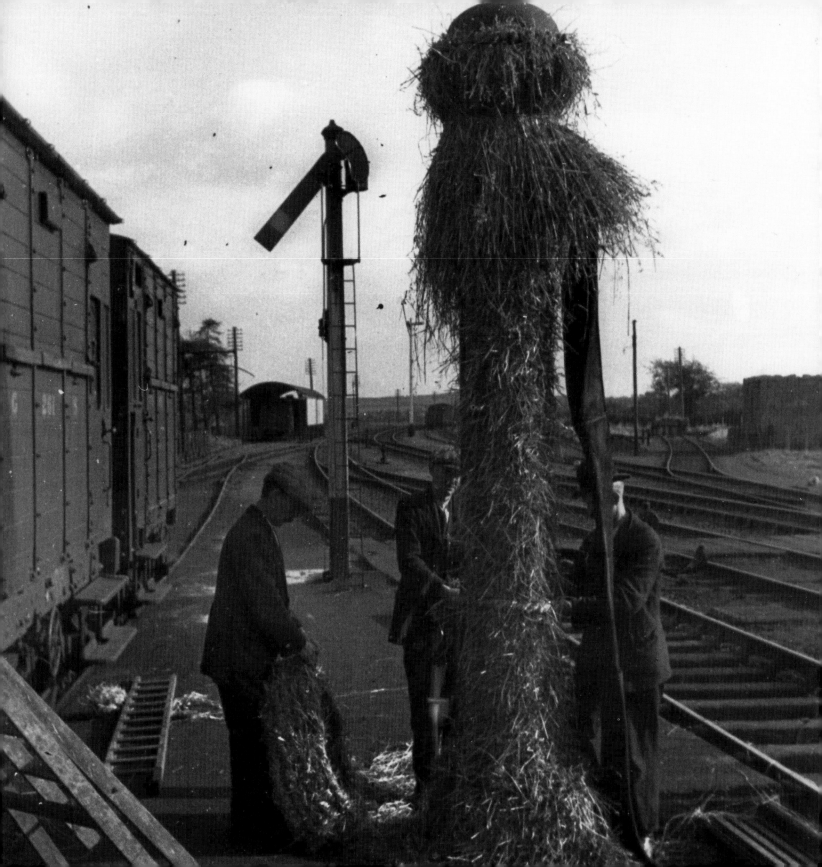

Curiosities and Crashes

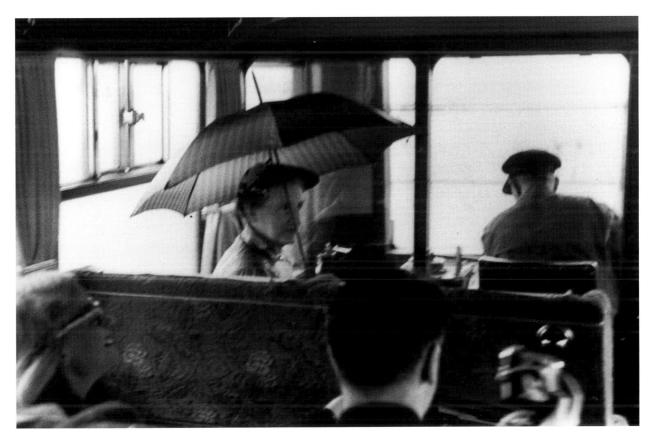

Above: A new diesel train lets in the rain! Lucan, Co Dublin (1954).

Opposite: Frost precautions, Portarlington, Co Laois (1931).

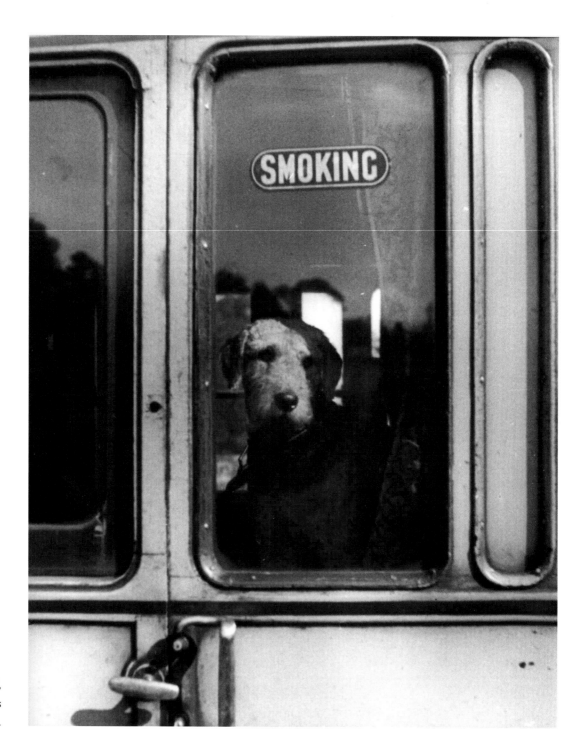

The 'non-smoker',
Portarlington, Co Laois
(1931).

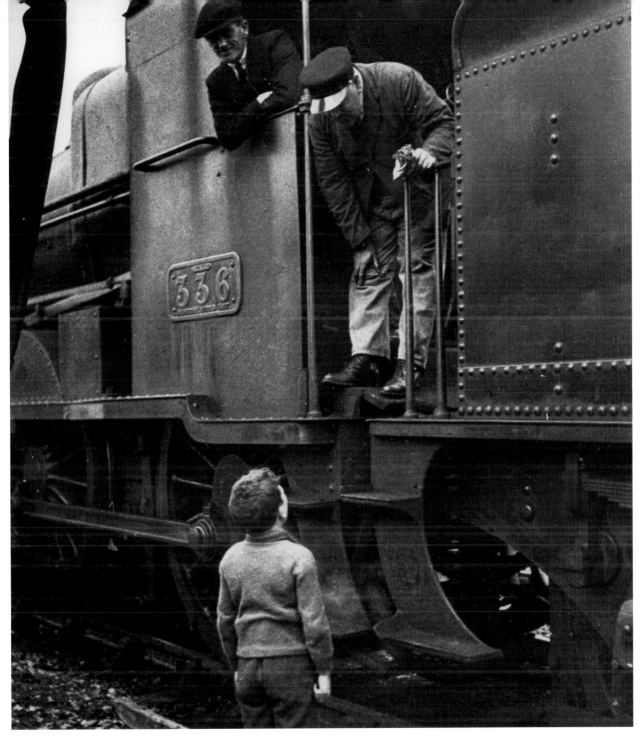

'When I grow up…' Dublin (1930).

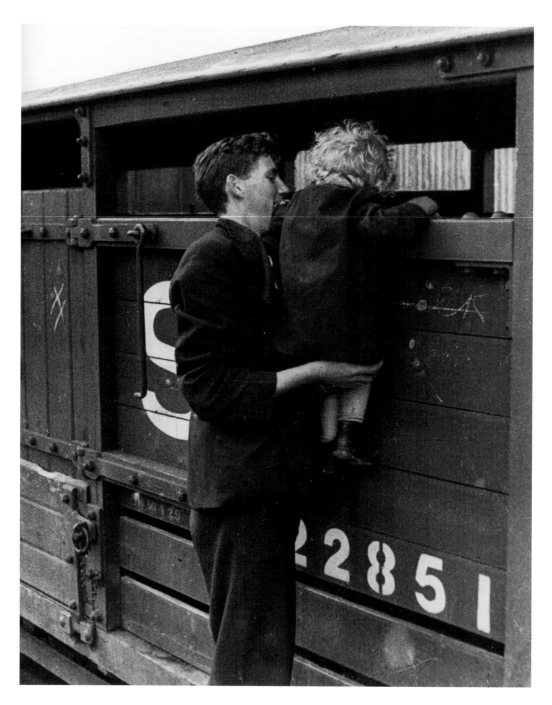

'Looking in.' Liffey Junction, Dublin (1942).

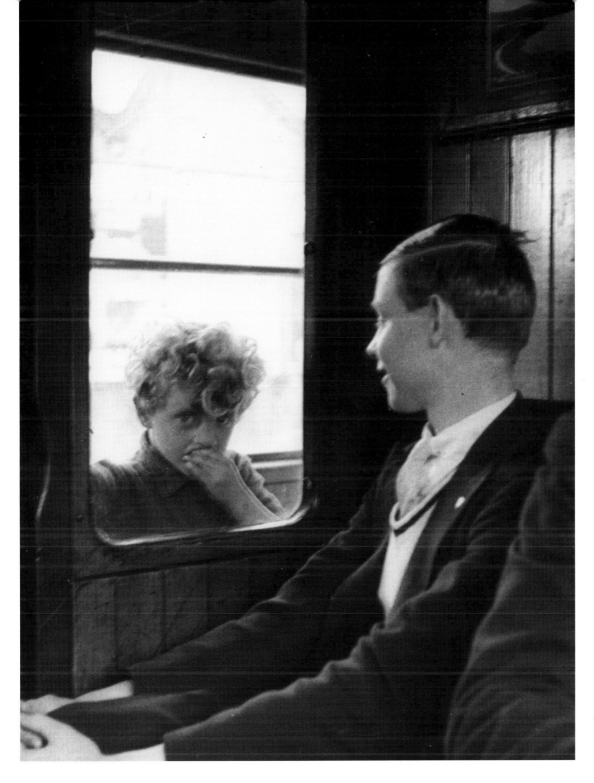

'The face at the
window.'
Harcourt Street,
Dublin (1933).

Detail of windscreen wiper, locomotive Number 801, Dublin (1940).

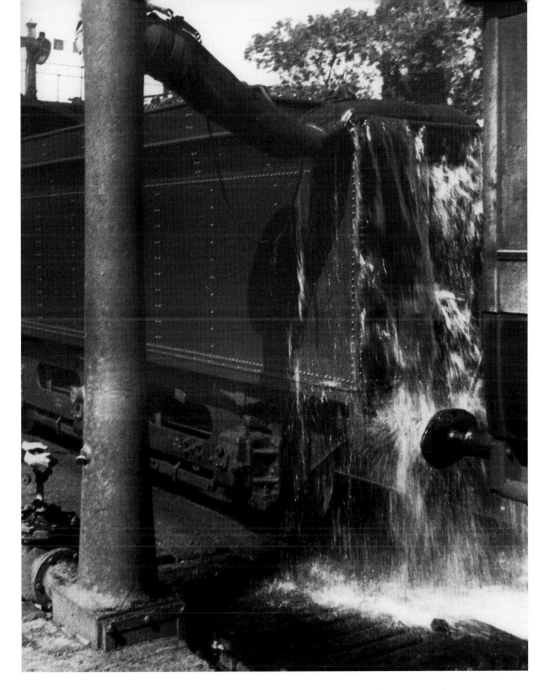

Morning shower, Portarlington, Co Laois (1933). This is a large 400 class engine taking water on a running track at the end of a platform and the tender tank has just overflowed.

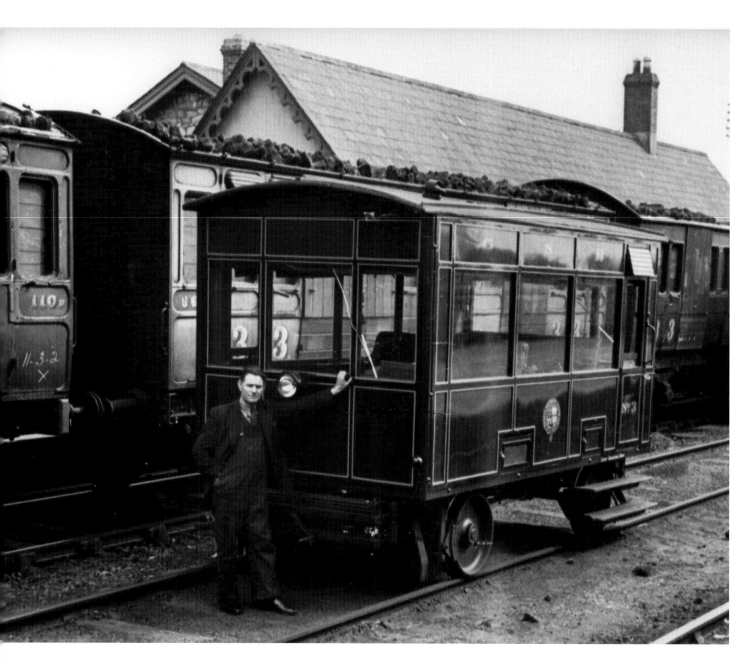

Engineer's rail-car at Portarlington, Co Laois (1942).

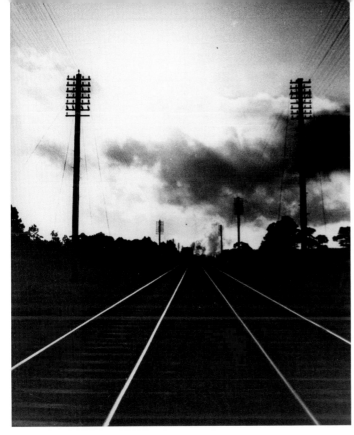

Left: Vanishing point near Sallins, Co Kildare (1933).

Below: Birds on the wires, Castlerock, Co Derry (1934). The line here, between Belfast and Derry, once the LMS and then the Northern Counties Railway, is now part of Northern Ireland Railways.

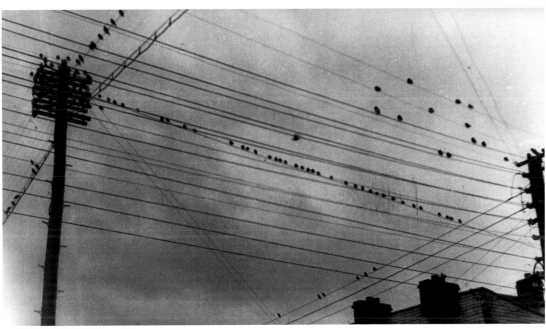

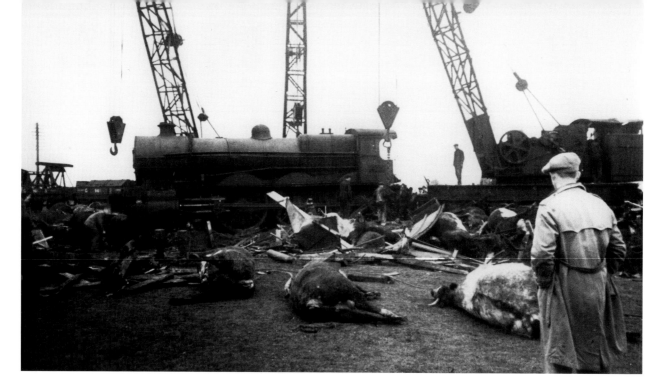

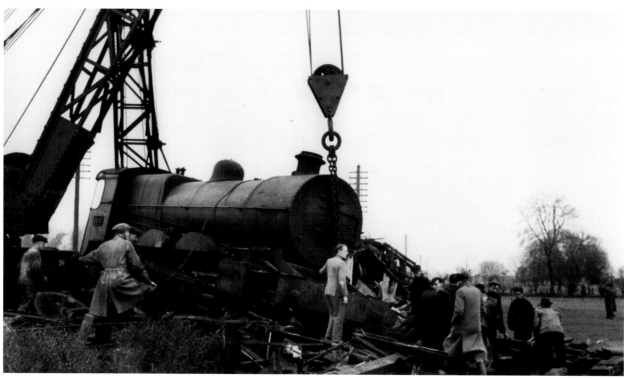

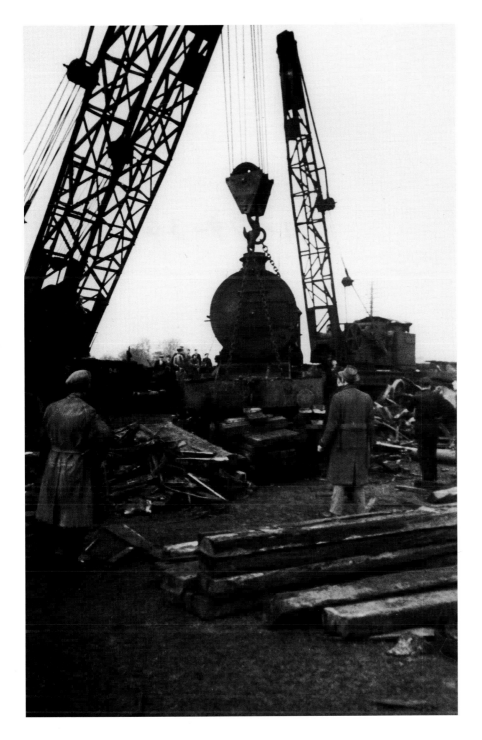

Wreck at Straboe, Co Laois (1944).

Shortly before midnight on 20 December 1944, in the very last days of the GSR's existence (CIÉ taking its place at new year 1945), the company suffered its worse rail accident in a twenty-year history. The heavy Dublin to Cork Night Mail, crowded with passengers as well as full of mail and perishable goods in that pre-Christmas period, slammed into the back of a stationary cattle train some five miles south of Portarlington Station.

No passengers were killed but one Post Office official was fatally injured (the only instance of accidental death of a non-railway person in the history of GSR) and there was a great loss of livestock. The large engine of the Mail, Number 406 (a sister to the engine involved nearby in 1940 shown earlier), which took the brunt of the impact, took much time and effort to be re-railed as the photographs show, requiring four giant steam cranes to be lifted.

It was a traumatic event for railwaymen at that time, and resulted in a public inquiry and a trial in the Central Criminal Court. But Number 406 was soon repaired and in service again – so strong was the design and construction of steam locomotives.

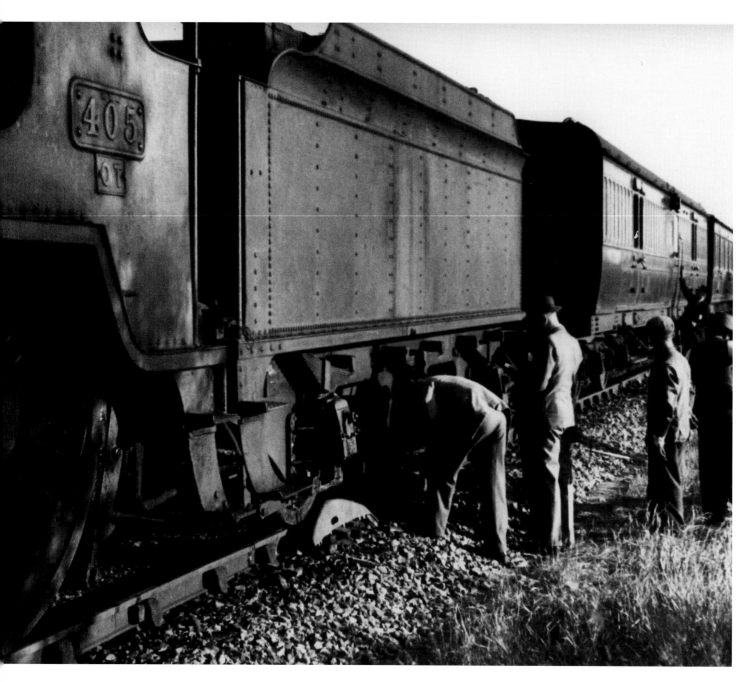

Derailment of the up afternoon train from Cork, involving locomotive Number 405. This took place opposite Shaen Sanatorium, Co Laois, not far from the Jesuit Novitiate at Emo where Father Browne was residing (1940).

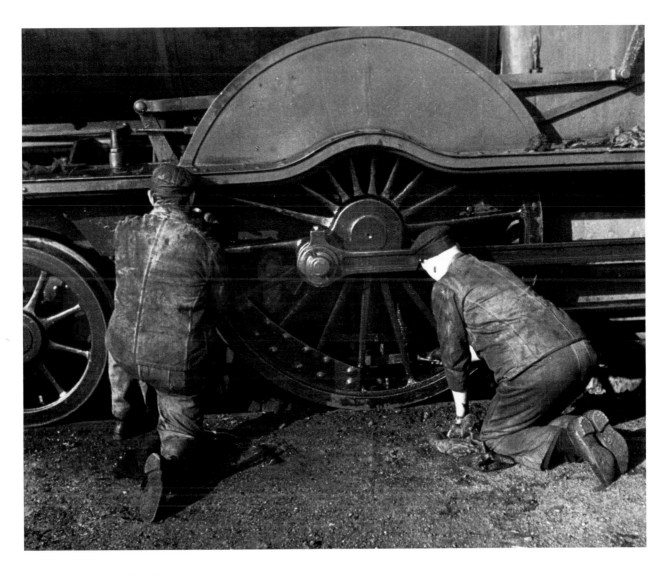

Derailment at Cork (1930).

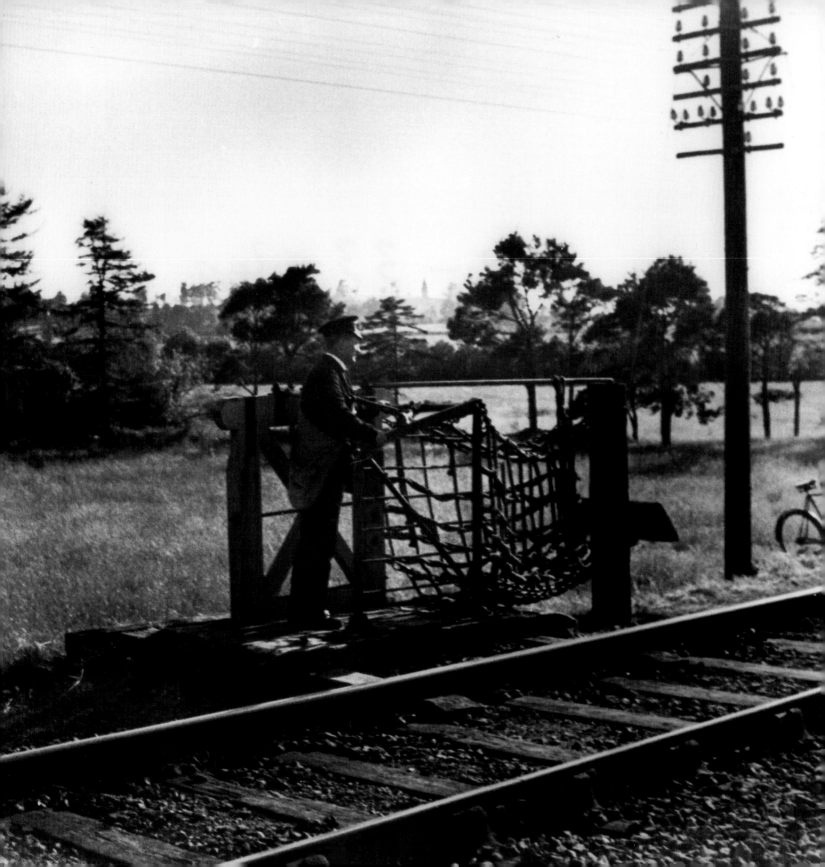

The Travelling Post Office

Above: Letters and instructions being received on the Travelling Post Office carriage of the Dublin-Cork Mail Train, Kingsbridge, Dublin (1930).

Opposite: The mail cage (1937). In the morning, the ground net before Portarlington Station is extended in readiness to collect the mail off the down-Mail passing through from Dublin.

Afascinating series of pictures, taken when the mails, especially to and from Britain, were collected and released at speed by the express Day Mail trains on the Cork line. This was, incidentally, a common feature on major lines, and immortalised in the excellent 1930's documentary film *Night Mail*, on the LMS line running between London and Scotland, for which W. H. Auden wrote a poetic commentary and Benjamin Britten composed the music. In the case of GSR, Father Browne went to a lot of trouble to photograph the drama of their operation, showing how the morning mails for local delivery were collected at the lineside near Portarlington off the down-Mail, while those for mainly English destinations were snapped up by the speeding up-Mail in the evening. And he travelled both in the TPO (Travelling Post Office) on the train and on the locomotive footplate alongside the crew to capture the atmosphere aboard. An eyewitness has described his subsequent arrival in Cork begrimed with coal dust and smuts!

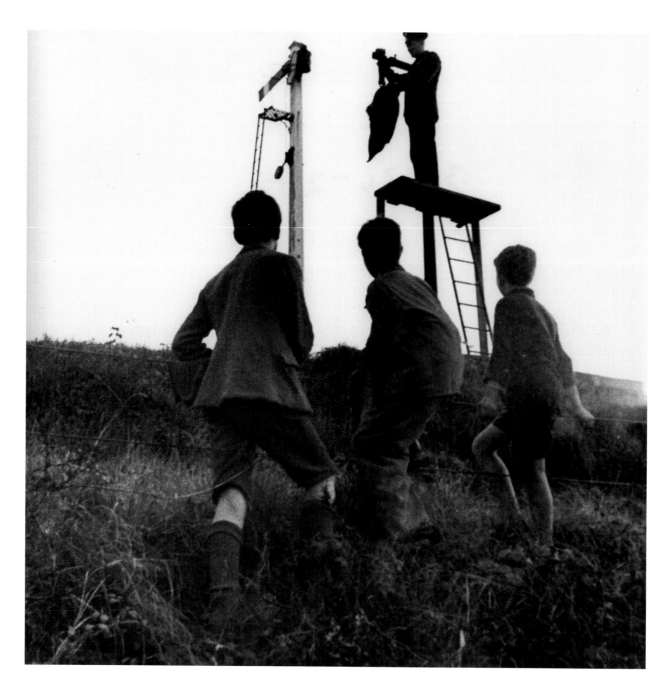

Boys watching the hanging (1937). Under watchful eyes, mail for further down the line is set up for snatching by the train at the same time as the ground net collects the arriving mail.

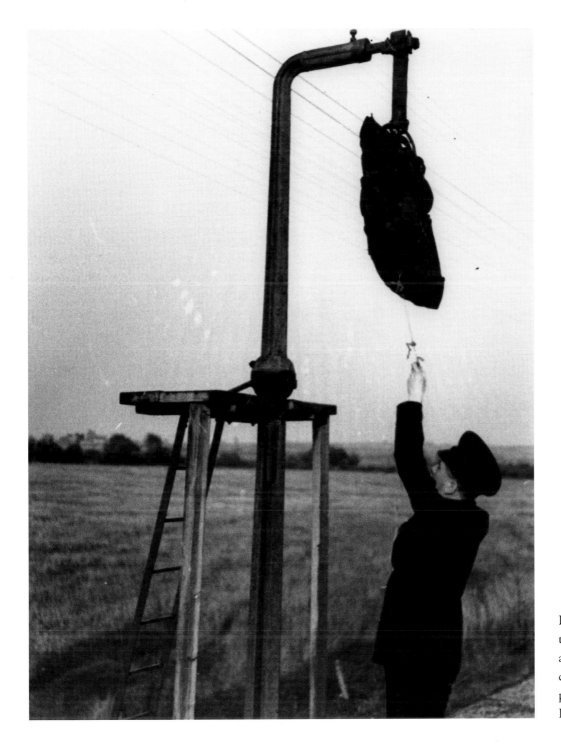

Dangling the mail (1937). In the evening, mail for Dublin and Britain is hung up for collection by the up-Mail passing through on its way to Dublin and Dún Laoghaire.

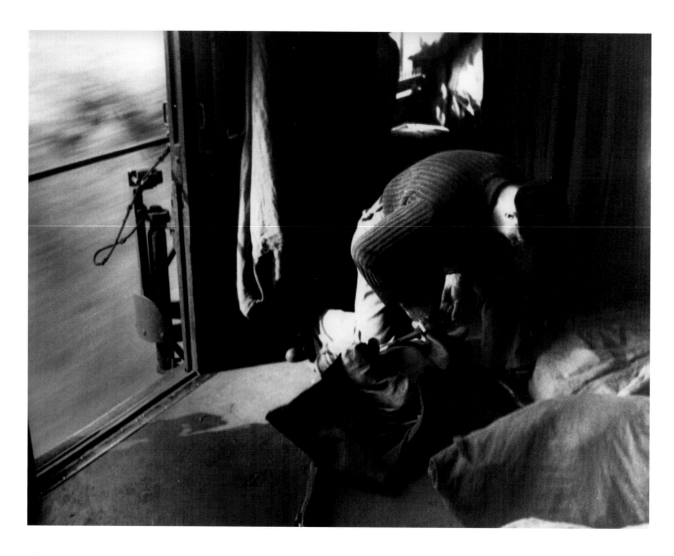

Close-up of snapper (1937). The Portarlington mailbag is prepared for delivery.

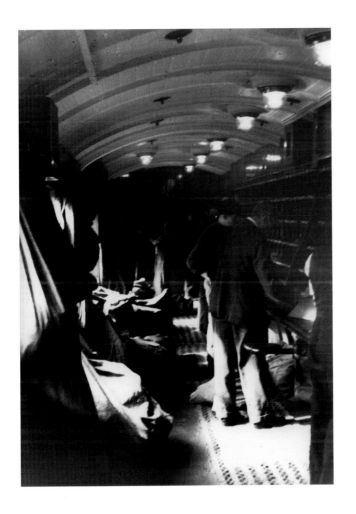 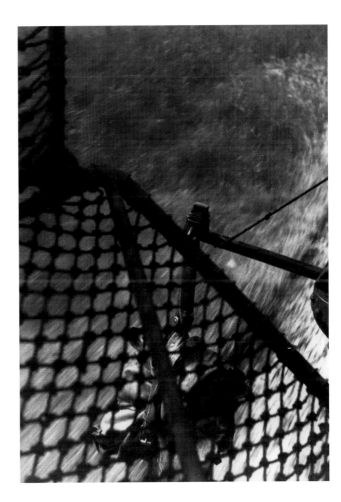

Left: Sorters at work (1937). In the TPO on the train itself, mail bags are lined up for delivery.

Right: The grasping-net (1937). The bag has been swung out from the speeding train and is about to be snatched, while the grasping net simultaneously will take on board mail for the south.

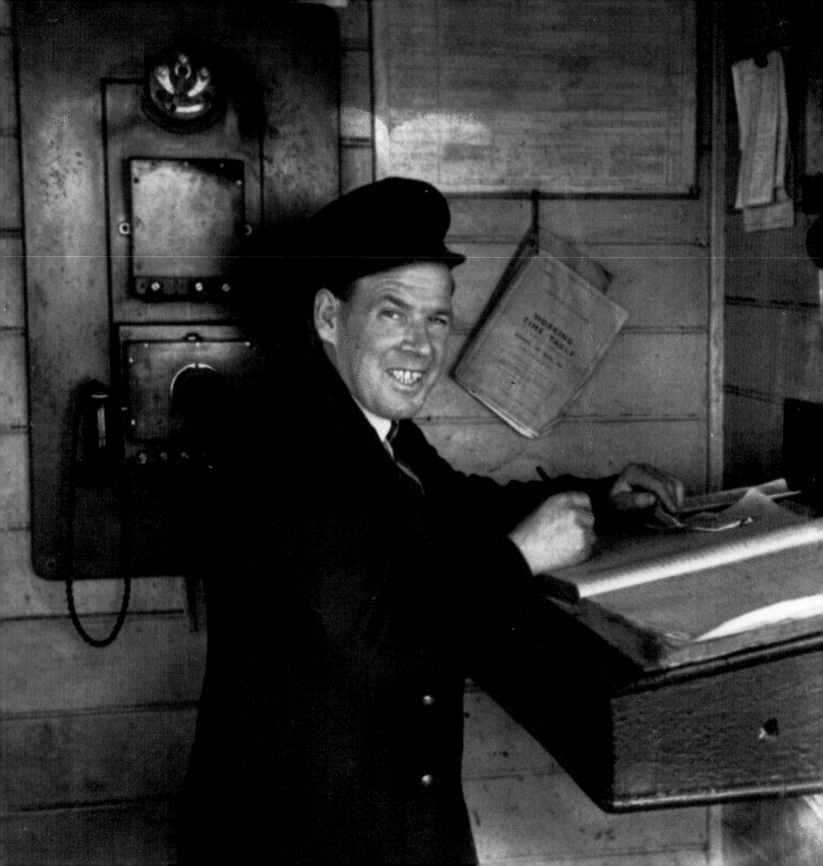

Railway Personnel

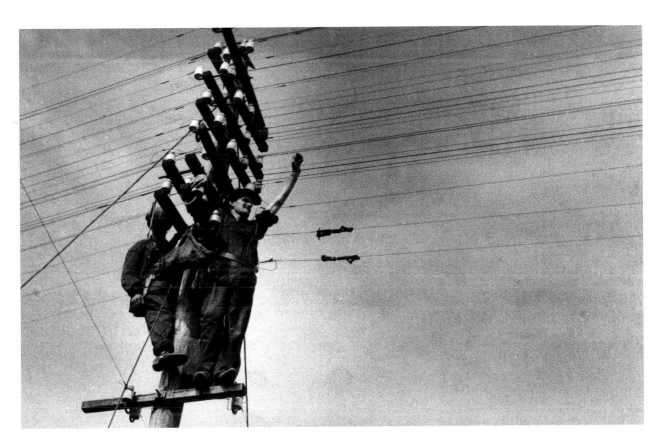

Above: 'High Wire Act' near Portarlington, Co Laois (1953).

Opposite: Signalman A. Cooney at Balbriggan signal-cabin, Co Dublin (1946).

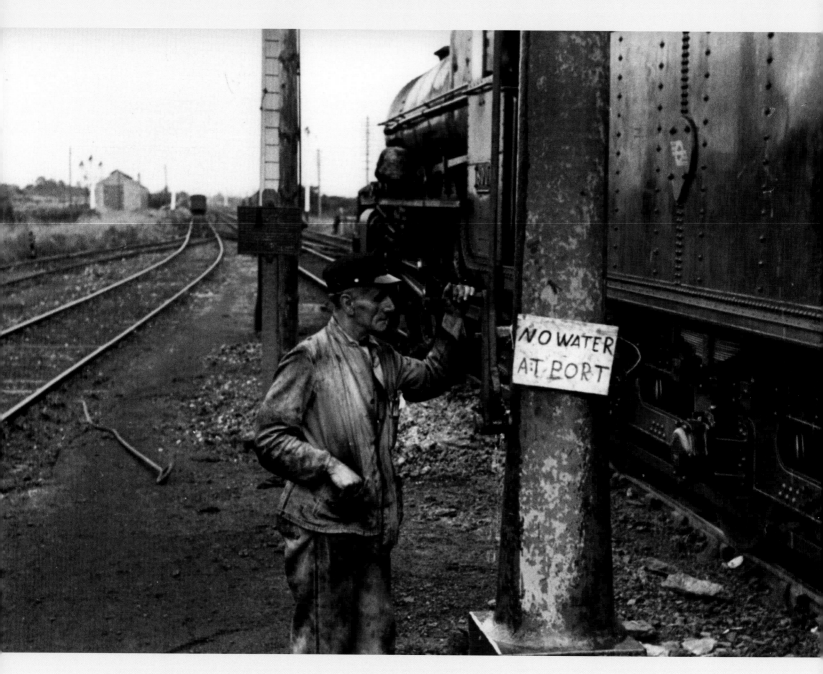

Notice at Kildare Station referring to drought at Portarlington, Co Laois (1946).

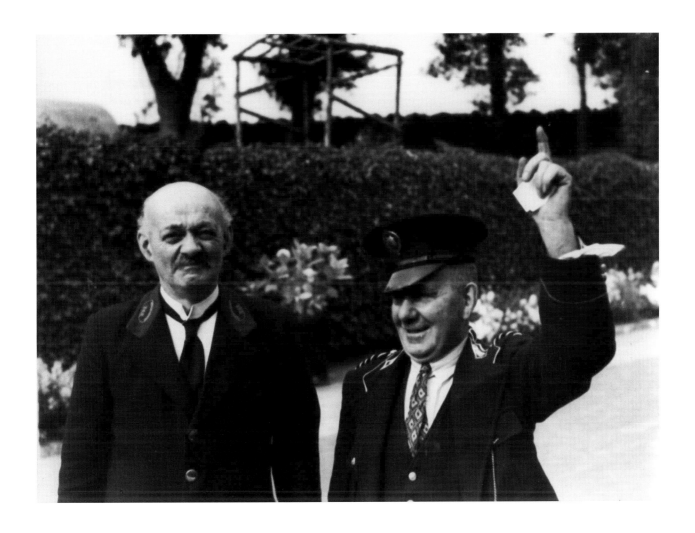

'Railway Personalities' (1940). F. Sullivan and B. McEvoy are photographed at Cloughjordan Station, Co Tipperary.

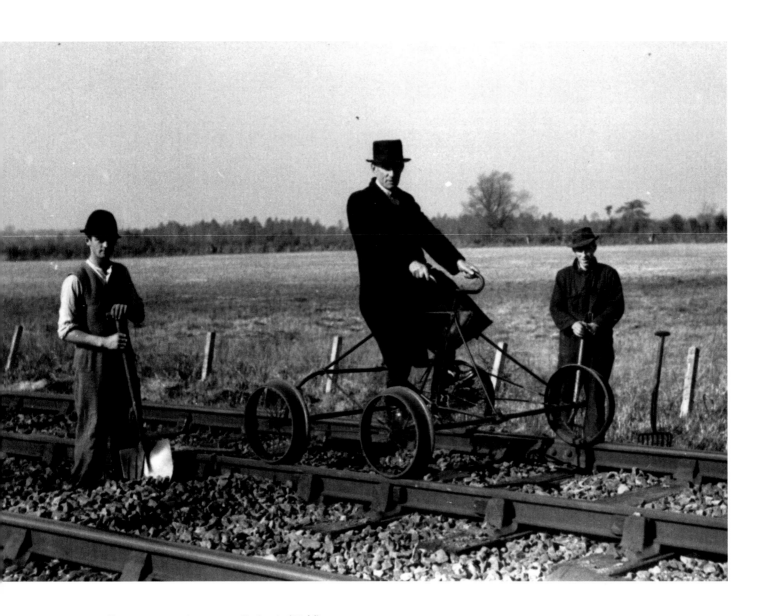

Permanent way inspector, Co Laois (1944).

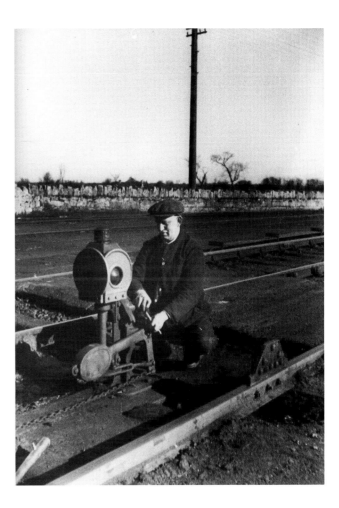

Left: LMS signalman at Mossley Hill, Liverpool (1947).

Right: Adjusting points disc-signal at Portarlington, Co Laois (1932).

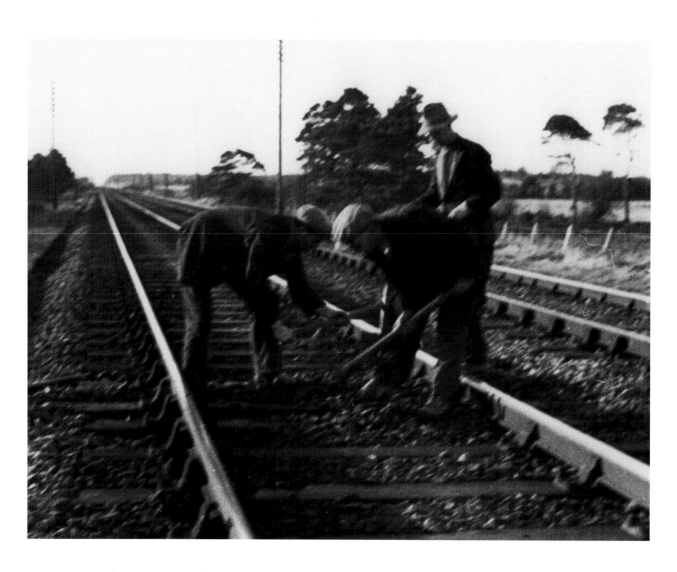

Linesmen at work near Carne Bridge, Co Laois (1932).

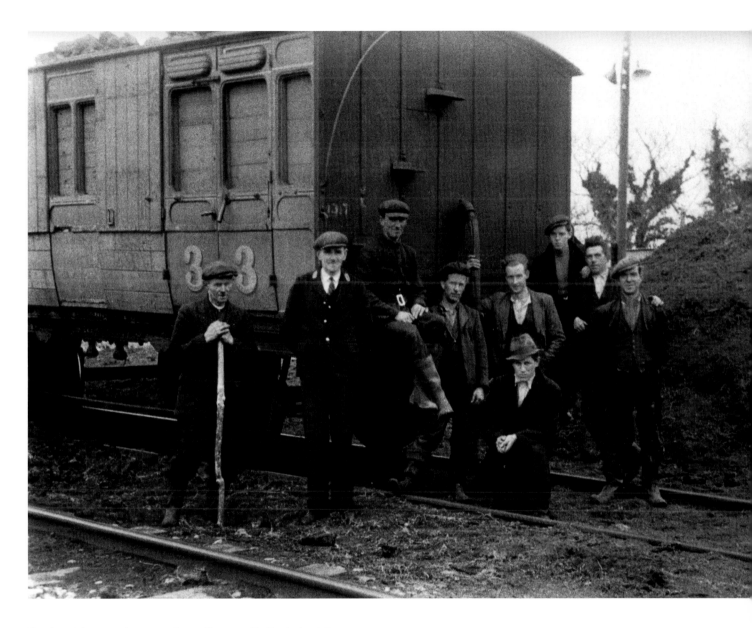

Bord na Móna workers near Portarlington, Co Laois (1943).

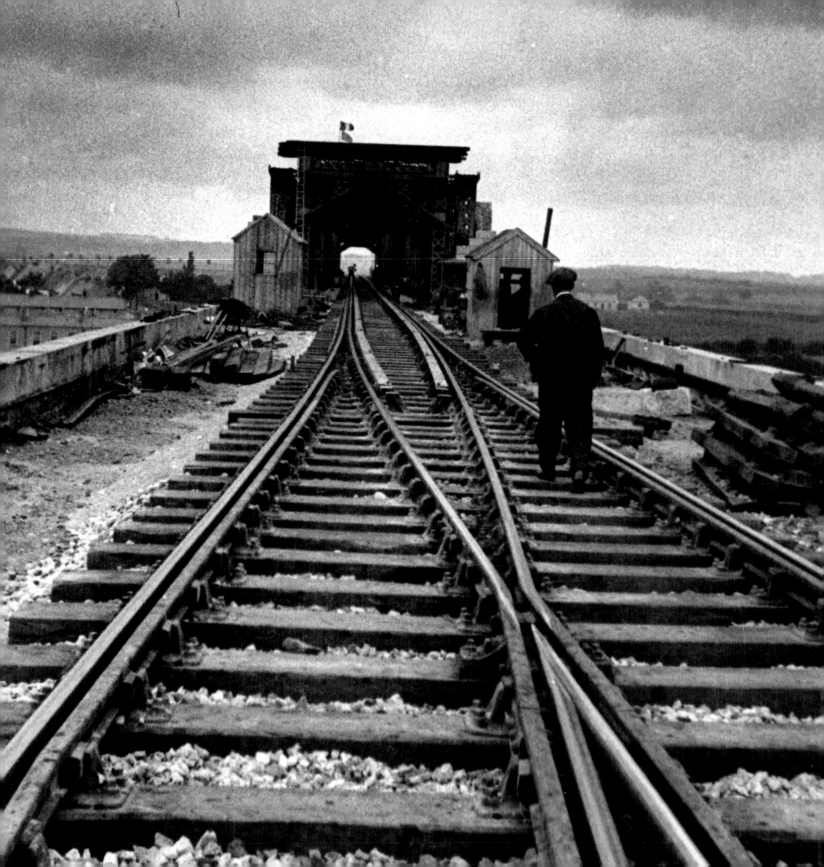

Views from Trains

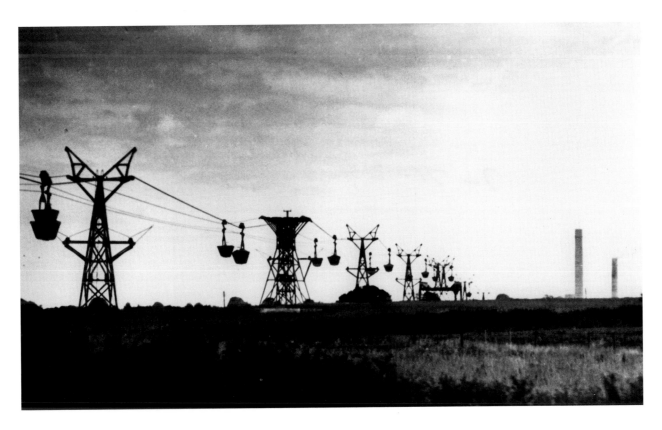

Above: Gravel-buckets heading for the cement factory at Drogheda, Co Louth (1942).

Opposite: A view of the interlacing tracks replacing the former double line on the new Drogheda viaduct, being constructed to carry the new GNR Compound express locomotives introduced in 1932. The Boyne viaduct here dates back to 1844.

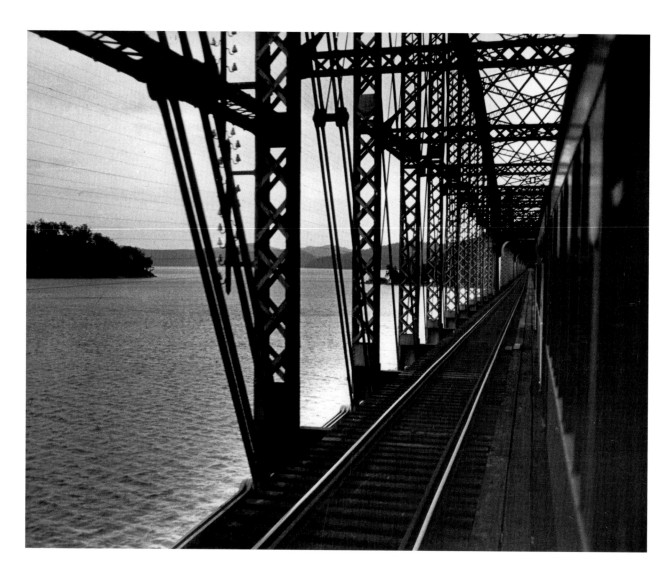

The Sydney-Brisbane railway crossing the Parramatta River (1925).

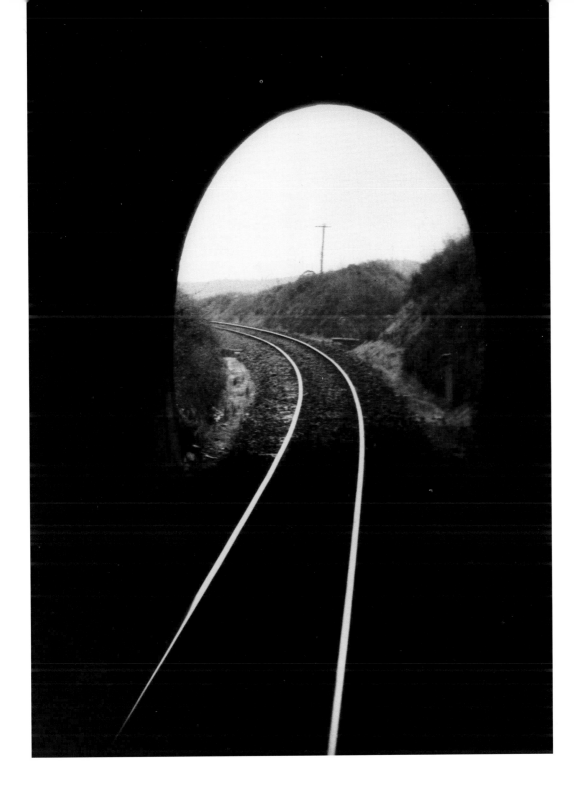

From the footplate of the
Sydney-Brisbane Express
(1925).

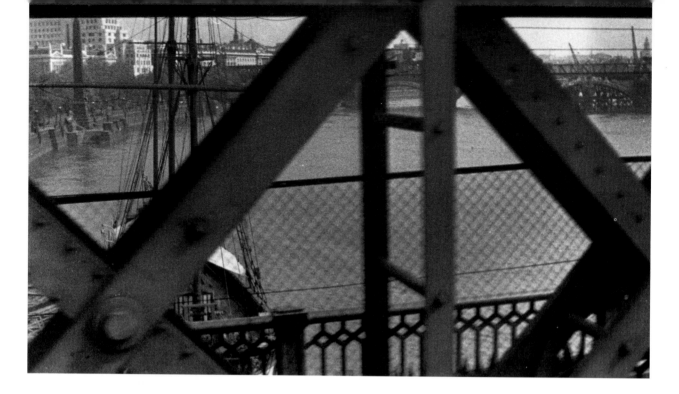

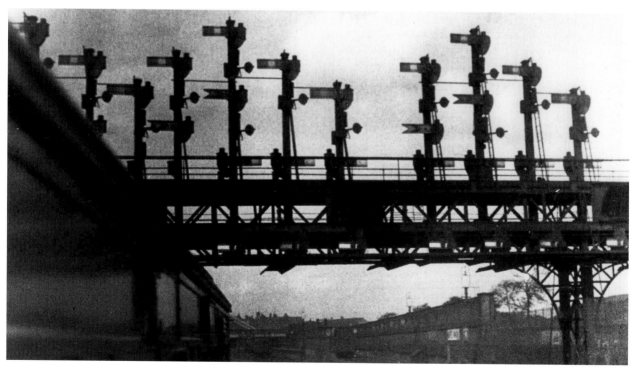

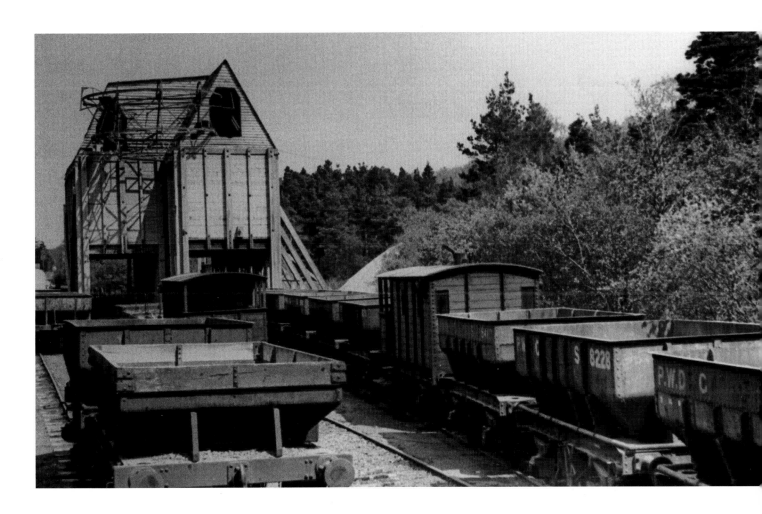

Opposite, top: Crossing the River Thames (1930). Cleopatra's Needle can be seen on the Victoria Embankment, left.

Opposite, bottom: A gantry of signals at Crewe, Cheshire (1930).

Above: Lisduff track ballast quarries, between Ballybrophy and Templemore (1942).

Unwanted guests on the Tralee-Dingle track near Lispole, Co Kerry (1942).